PORCHES
ART AND RENEWAL ON RIVER STREET

Photographs by Nicholas Whitman

Essays by William Morgan,
Joe Manning, and Nicholas Whitman

Edited by Jennifer Trainer

MASS MoCA Publications
North Adams, Massachusetts

© 2002 MASS MoCA. All rights reserved.

Distributed in the United States by teNeues Publishing Co.
16 West 22nd Street New York, New York 10010

All Nicholas Whitman photographs © Nicholas Whitman.
Used by permission. View other Nicholas Whitman photographs at www.nwphoto.com.

 MASS MoCA Publications
1040 MASS MoCA Way North Adams, MA 01247
PH 413.664.4481 www.massmoca.org

All Burr & McCallum Architects drawings reproduced in this book used by permission. All rights reserved.

This book is made possible by the generous support of the Berkshire Hills Development Company.

For more information on The Porches Inn, write to them at 231 River Street, North Adams, MA 01247 or call 413.664.0400, www.porches.com

ISBN: 0-9700738-6-0

Photographs on pages 20 & 21 courtesy of Annette Duprat.

No part of this publication may be reproduced in any manner whatsoever without written permission from MASS MoCA.

Art direction and jacket design: Doug Bartow / MASS MoCA

Production and layout: Diane Gottardi

Printed in Canada by Transcontinental Printing Inc.

The dust jacket was printed four color process + pms 1817 and pms cool grey 5 on 100# dull coated text, and finished with a matte lay flat film laminate.

The text pages were printed four color process plus spot satin varnish on 100# dull coated text.

Principal typeface: Joanna (Monotype)

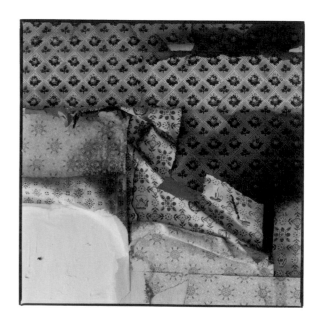

This is the story of a guy with guts and vision, a woman with business acumen and élan, and a small mill city in western Massachusetts in the midst of dramatic economic rebirth.

With eyes the color of Sinatra's and as penetrating as a tiger on the hunt, Jack Wadsworth is the kind of guy you'd rather have on your side. Direct, funny, smart, and accomplished, he's not uncharacteristic of many Williams College alums who gravitate back towards the Berkshires' purple mountains. As a trustee of nearby Williams College and of the Guggenheim Museum in New York (and formerly chairman of Morgan Stanley Asia), he watched the phoenix-like rise of MASS MoCA from mill to museum with curiosity and interest. Here was what at first blush could be perceived as a hare-brained idea – the transformation of a 13-acre 19th century mill complex in a blue-collar mill city into one of the world's largest and most ambitious centers for contemporary art – except that it actually worked. Since opening in 1999, the Massachusetts Museum of Contemporary Art (MASS MoCA) has attracted more than 120,000 visitors a year to North Adams, gaining a reputation as a laboratory for some of the most important large-scale works of performing and visual arts being made today.

What Jack Wadsworth found equally curious was museum director Joseph Thompson's novel solution to the institution-threatening problem of no endowment: four years before the museum opened, Thompson began converting 50,000 square feet of museum space into commercial offices, renting them out to innovative companies with sympathetic artistic sensibilities – a publishing firm, a Hollywood special-effects company, internet gurus, even a company that promotes Peace Corps-like activities for techies. Their rent helps fund museum programs.

When Thompson approached Wadsworth in 1995 for a flat out gift to suppport this fledgling commercial operation, Wadsworth countered by offering to jump-start the idea by proposing an ingenious private matching gift that would trigger additional state funds, make donors feel like they were leveraging a handsome return on their gifts, and place strong financial incentives on MASS MoCA to develop commercial space quickly. (It didn't hurt, either, that he dangled the carrot of a large bonus to the museum if Thompson could pull off the challenge within a year.) Then Wadsworth sat back and watched as MASS MoCA attracted half a dozen tenants that today support museum operations by nearly half a million dollars yearly, with the figure growing steadily.

As MASS MoCA was under construction, Wadsworth stayed in the background, dropping by when he was in town for a Williams trustee meeting, keeping vaguely in touch. When MASS MoCA opened in May 1999, Thompson offered Wadsworth a tour, and they found themselves standing in a gallery looking out the window at a row of former mill houses across the street from MASS MoCA in one of the city's poorest neighborhoods. Dilapidated, half-abandoned, and with enough code violations to earn the owners the nickname of "slum land-lords," these 19th-century row houses were once dignified, even stately. Wadsworth could see the remnants of quality craftsmanship in the slate roofs and in the fragments of architectural detailing that weren't covered by asbestos siding, and he found their location intriguing: they faced the museum and the Hoosic River, and backed up dramatically against the hills that give North Adams its unique character. Wadsworth suggested that MASS MoCA buy the block, clean it up and somehow incorporate it into the museum's real estate plan.

"That's a terrific idea," Thompson countered in his quiet Oklahoma drawl. "Why don't you do it?"

Wadsworth laughs when recalling this conversation. What amuses him even more was that six months later (after he decided to buy the block of properties and was planning to turn them into rental units) Joe called and said that one of his trustees (Nancy Fitzpatrick, who owns The Red Lion Inn, which Wadsworth

now refers to as the "Mother Ship") wondered whether Wadsworth would consider turning the houses into a hotel.

"I told Joe that is THE dumbest idea I've ever heard in my entire life."

But Wadsworth said he'd hear Fitzpatrick out, and when she met him three months later in New York – armed with a vision, a five-year forecast of terms for a joint venture, and her hotel expertise – they had a handshake agreement in 45 minutes, and The Porches Inn was created. Wadsworth and Fitzpatrick even used the same lawyer so as not to waste time or money.

"Even before MASS MoCA opened," recalls Nancy Fitzpatrick, who has been fond of North Adams ever since her father, State Senator Jack Fitzpatrick, campaigned and won the hearts of the mill workers in North Adams in the '70s, "I started fantasizing about creating a cool lodging property in one of the city's old buildings. One site I really liked was the row of finely detailed, ramshackled houses on River Street that dominate the view from several galleries at MASS MoCA." One day, standing by a gallery window with Thompson, she remarked that those buildings would make a great hotel. "Aren't they too close to the road?" he asked. "At The Red Lion we've been right on a road busier than River Street for more than 200 years and we've survived."

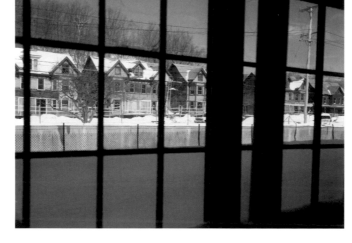

View of Porches before renovation
(from Gallery 5 at MASS MoCA).

Eighteen months later, in June 2001, The Porches Inn greeted its first guests. The five Victorian-era buildings that were originally constructed as worker housing during North Adams' industrial heyday now have high-speed data connections, DVD players, and funky memorabilia on the walls reflecting the region's historic Mohawk Trail. Behind the inn is an elegant outdoor pool, open year-round, that

steams invitingly in the dead of a snowy winter. (There is nothing of the usual "Victorian B & B" about Fitzpatrick's treatment of the buildings.) The neighborhood is still reflective of changes underfoot throughout the city; from the porch of this *Travel & Leisure*-awarded "Inn of the Month" one can still go across the street to get one's car washed, and with the mayor's help there will one day be a park on the site of the Eightball Auto Shop that now dominates the view.

To understand the changes underfoot, one must understand the uneasy truce between North Adams, a proud mill town, and its neighbor Williamstown, home of Williams College and the self-proclaimed "Village Beautiful." MASS MoCA has done much to soften the socioeconomic divide between these two isolated towns nestled in a valley of the Berkshire mountains, mostly through increased commercial, educational, and political cooperation and traffic. But still, considering that a developer in the mid-1980s suggested the best use of North Adams property would be to flood the city to make waterfront property for Williamstown, Wadsworth was asked whether his role as a Williams trustee had anything to do with his investment. He admitted that, while his involvement in the affairs of the College allow him to see the fabric of the region in more detail than some, he takes an historical view of the Northern Berkshire region. "This region has been a destination for tourism that has been driven by culture and geography, and a destination for college students. To make the economy viable in the long run, you also need some appropriate level of business activity," he said, citing the textile mills of the 1800s (that prompted the construction of the row houses that today are Porches), the giant electronics factory in the mid-1900s (on the site that eventually became MASS MoCA), and the small "new economy" businesses of today. "The political leadership of North Adams – namely

Mayor Barrett—understands and encourages this, and that is a confidence-builder. The great global cities like New York and London always combine commerce, culture, and great academic institutions with a pleasing urban aesthetic. With culture and education already an essential part of the fabric of the Northern Berkshires, the missing piece is commerce – enter North Adams."

"My vision – and it's evolved from 'let's clean up the block' to 'let's build a hotel' to 'how do we actually make this hotel pay off?' – is to have North Adams become a significant location for small and medium-sized businesses, which I think will be the centerpiece of the economy of the northern Berkshires," continued Wadsworth. "So if MASS MoCA is providing the incentive for office space, and you have a first-class small hotel, good restaurants, and a template for the kind of entrepreneurial businesses that work in the northern Berkshires, this might just all coalesce. After all, what could be more curious than to have eZiba, an internet-based marketing and distribution company for arts and crafts produced in less-developed countries, located in North Adams, Massachusetts – that says it all!"

This book is about the evolution of Jack Wadsworth's vision, Nancy Fitzpatrick's business intuition, and the gumption of people who attempt to help revitalize a city. The book is also about sensitive urban renewal, and about enlightened architectural design that transforms a property while respecting the history of its place. And, in the words of photographer Nicholas Whitman, this book is about the "back and forth" through the windows: from the people in the early 1900s who looked out the windows of their River Street apartments to the mill where they worked across the river (and then, while at work, looked out the mill windows to their apartments) to the entrepreneurs, architects, and museum visitors of the 21st century who look through those same windows, from the museum to the inn, and from the inn to the museum, and see a parallel sort of socioeconomic interaction across River Street. It's a way of viewing things.

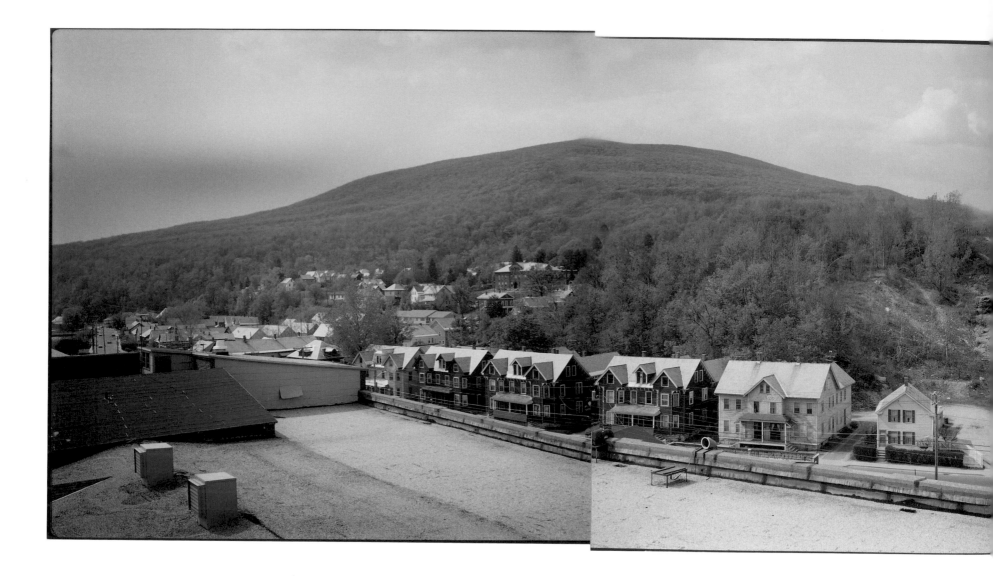

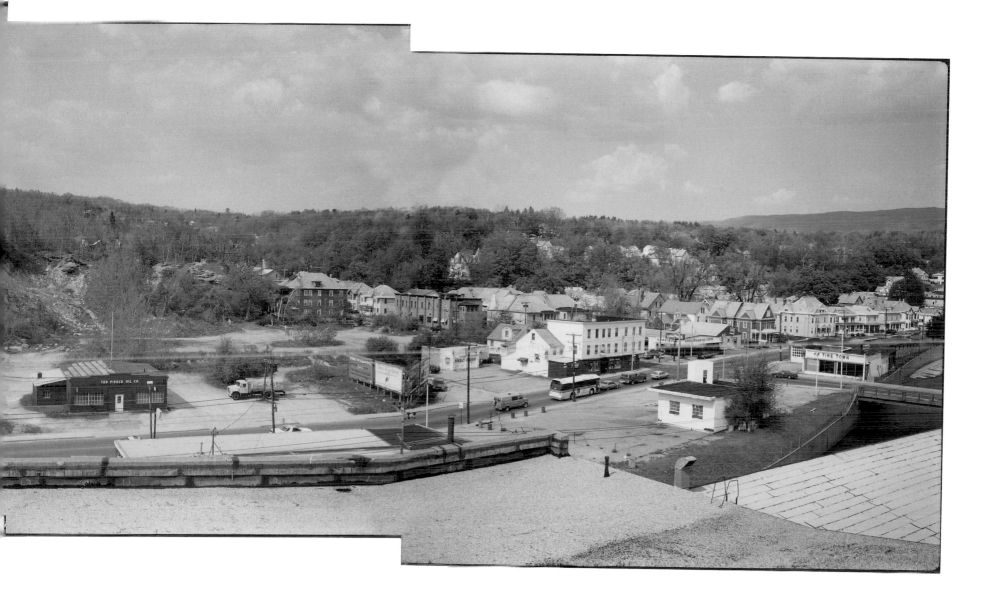

Machine-made scallops, incised patterns, and tiny rosettes decorate the doors on the houses of River Street. Large single panes in the doors serve as mirrors, reflecting a long brick mill building across the Hoosic River.

The mill, once the great engine that drove the industrial might of North Adams, is now MASS MoCA. The houses, built for mill workers, have become The Porches Inn. Together these structures form a symbiotic relationship of labor and management, of ingenuity and creativity, and of the city's manufacturing history and its phoenix-like future.

Mill and houses are also bound together by the topography of the Berkshires. The gray mountains close in around North Adams, defining it as a place distanced from the world. The bittersweet sound of a train whistle echoing through the valley has always been a sign of commercial progress and a lonely wail. North Adams a century ago might have been defined as a utopian experiment – yeoman workers in an idyllic setting without the distractions of city life. But to the Welshmen, Italians, and Chinese who labored in the textile shops, shoe factories, and carriage works, at times North Adams must have seemed like a dark valley with a limited horizon.

At its peak, North Adams had less than 25,000 people, hardly a Massachusetts mill city of the magnitude of Holyoke, Lawrence, or Lowell. There was no broad valley floor to expand upon (an 1881 bird's eye view of the city shows the undeveloped hill rising behind River Street, looking much like it does today). But while the mountains limited industrial growth, they also maintained a small town feel, reinforced by parish-sized immigrant communities, vestiges of which are still apparent, for example, in the division of Catholic churches into Italian, Irish, and French-Canadian parishes.

Porches

BY WILLIAM MORGAN

This map shows the original Arnold Print Works (now MASS MoCA) as it stood between the north and south branches of the Hoosic River in 1880

The frame houses of River Street's north end neighborhood capture the intrinsically contained quality of North Adams. These were not single-family homes – many, like those that now make up The Porches, were quite large – but the use of wood fostered a domestic scale. There is nothing in North Adams like the vast masonry dormitories of Lowell, nothing of the endless horizon of stark brick row houses in the English Midlands. North Adams' geographic compactness meant that housing was not built progressively farther from the mill, but, rather, stayed close to the work site.

There were several mills close by, such as Calvin Sampson's shoe factory and the Windsor Print Works (which began in the 1830s as the Estes Fulling Mill). But it was the Arnold Print Works on Marshall Street that dominated the economic and social life of the city.

The original Arnold Print Works, built in 1860, was destroyed by fire in 1872. Alfred C. Houghton, North Adams' best-known industrialist, bought the remains from the Arnold brothers. Besides consolidating the various Arnold subsidiaries in nearby towns and bringing in the latest cotton dyeing machinery, Houghton undertook a major expansion on Marshall Street over the next 30 years, shaping what is today's museum site. Houghton was perhaps the primary beneficiary of the Hoosac Tunnel, a stunning engineering feat that pierced the high granite ridge rising at the eastern perimeter of North Adams (forming the longest tunnel in the world at the time). Suddenly North Adams found itself situated on the main commercial transportation route connecting Boston to the east and the Great Lakes to the west.

Arnold Print Works remained the chief manufacturer and employer in North Adams, surviving and even thriving during the Depression. It made cloth for Union army uniforms during the Civil War, and prospered by offering designer fabrics to an international market. But, unable to obtain enough government orders at the outbreak of World War II, Arnold Print Works folded in 1942, a victim of the generalized decline in textiles in New England as manufacturing sought cheaper supplies and labor elsewhere. R.C. Sprague secured the vacant factory complex for his new company, which specialized in electrical components. Sprague Electric Company's condensers and other inventions were more in tune with the radio age (and modern warfare), and Sprague prospered at the Marshall Street complex for four decades. Anyone who built a Heathkit radio knew who made the best electronic components: "Don't be vague, ask for Sprague!"

Not all the people who lived on River Street before World War II worked at Arnold Print Works, but the mill bell defined most everyone's life with Pavlovian predictability. The River Street houses, constructed around 1900, echoed Houghton's second big expansion at the Marshall Street mill. By 1905, over 3,000 people worked for Arnold Print Works, then one of the world's largest producers of printed textiles.

In his pioneering Yale dissertation, *Industrial Architecture in the Berkshires*, William Pierson singled out Arnold Print Works as an example of "profit-oriented construction," and argued that businessmen were no longer concerned with nurturing the communities that supported their operations. The River Street tenements, too, were clearly speculative. Yet, there is a special quality about these houses that transcends their origins and that has successfully carried over into Porches' conversion.

River Street development began in the 1890s, although there was considerable activity from the early 19th century. A block of tenements on Houghton Street was built around 1850 for workers in the Stone Mill (a handsome granite block that stood on River Street until about 1900). In the early 1890s, George Chase enlarged these as his home after he became the president of C.T. Sampson

Manufacturing. This shows the fluid, non-monolithic nature of domestic construction in what has been called, perhaps somewhat optimistically, North Adams' first middle-class neighborhood.

The poolhouse behind Porches is a simple rectangular 1850 frame dwelling that is the lone survivor of this early period. There were similar houses arrayed from the Stone Mill to Veazie Street, but these were razed to make way for the block of houses on River Street that would later become Porches. At the west end of the block stood the residence of T.F. Loftus, built just after 1885. A few years earlier, Loftus was living at number 297, and he built many of the row houses nearby. Since Loftus was involved in real estate, one wonders if he was the original builder of the River Street houses.

Whether it was Loftus or another contractor who built numbers 217-243 River Street, it seems certain that they were not erected by a mill operation solely for its own employees (which was a common practice elsewhere). Rather, they were commercial rental units for workers at various mills (the 1900 Sanborn map designates owner names of Armstrong, Collins, Costello, Craswell, and Hodge). City directories demonstrate that these houses were not let to one particular immigrant group. French-Canadians counted for 25% of North Adams' population in 1909, but River Street tenants and boarders appeared to be Welsh, Irish, and native New Englanders, as well as Québécois.

The North Adams Directory does not pair street addresses with occupants' names before 1915, but the 1917 and 1919 editions give clues to the ethnicity, workplace, and mobility of River Street's denizens. Number 217's residents, for example, Edward Horsfall and Charles Lee, both worked at Arnold Print Works. Number 219's Anna Supernault was likely a widow, and her neighbor William Armstrong (her landlord, presuming the same Armstrong from the 1900 map) was a chemist who was still living there in 1919. Wilfred Gaudette replaced Odile Poissant at number 223, while Arnold Print Works worker Herbert Horsfall lived in the other half of the house. Number 225's residents Semeilda Monet and Thomas Dunn, who worked at Hunter Machine Company, were long-time

occupants. M. Henry Gordon at number 229 transliterated into Mrs. Henry Godin; her neighbors were Ellen Stack and Thomas Williams, an employee of the Braytonville Mill.

One wonders if the seemingly high incidence of widowhood was due to the First World War or to the inherent dangers of working in the mills. Michael Fallon's neighbor at number 231 was, at first, Daniel Roe (listed as an ice boxer), and then Margaret Row. Similarly, Lucy Kelly at number 241 succeeded Robert Kelley who worked at Windsor Print Works.

Without knowing the positions these people held in the mills, it is hard to stake the claim of River Street as middle class (in the next block, some of the residents worked for Greylock Mill and for the Boston & Maine Railroad). Architecturally, the five houses were noticeably better than their neighbors, even if they do not begin to compete with the houses of the mill owners. One only has to look at the frame houses nearby, where dwellings of equal size and demeanor had almost no decoration, to determine that they were worker housing plain and simple. And the difference does not seem to be size or amenities, but more decoration and elaborateness of finish.

Number 217 has only one gable, but the other five houses have pairs of peaked gables, terminal points for semi octagonal bays. The gables are shingled with a fish-scale pattern, the cornices are bracketed, and the clapboard walls have strong articulation in the form of framing members that emphasize horizontal divisions as well as the corners. Available from local tradesmen, and following conventional patterns, these elements may not be inherently fancy, but they were combined with a sophistication that is not found on many other houses at this socioeconomic level. (Similar gable-and-turret treatments are found on

Bracewell Avenue and on now-demolished houses on Blackinton and Prospect Streets, perhaps the work of the same craftsmen).

Architecturally, these gables owe their genesis to popular mid-19th-century builders' handbooks by Andrew Jackson Downing and other tastemakers, who advocated replacing the dour foursquare Greek Revival temples with more romantic Gothic cottages. The peaked gable was a Downing trademark, but the framing is the product of a further picturesque development called the Stick Style, while the shingling is characteristic of the Queen Anne style. By the end of the 19th century, one can apply the all-inclusive label of "Victorian" to the increasing varieties of textural surfaces, over-abundant decorative detail, and complicated skylines.

Each of the large River Street houses was divided into four units (employing a U-shaped plan opening to the rear), but the fronts presented a more unified and formal prospect. The ensemble is thus grander than the usual worker housing, with its gables marching along River Street like holiday houses in a once-fashionable English seaside town. Even if not directly influenced by the architecturally ambitious estates of the same period in the affluent summer colonies of western Massachusetts, there is an accomplished sense about this grouping that suggests their developer wanted to dress them up. The River Street houses share details with some bigger homes in town (Bill and Judy Cummings' house at 182 East Main Street is a larger version of the River Street houses). Elegance does not necessarily require a lot of money; proportions and the right attitude can go a long way.

Best of all are the porches. There is nothing more quintessential about American domestic architecture than the front porch. The porch was an extra outdoor parlor. Maybe it only looked out across to the mill, but it caught breezes, and,

in a time before television, it served as a community living room. The original porches, like the bigger, grander veranda added by the hotel, were not at ground level, but raised up a few feet to give the residents a platform – a "belvedere" from which to look out.

Simeon Bruner, chief architect for the renovation of the former Arnold Print Works into MASS MoCA, said that MASS MoCA was "a new museum made from found buildings." The same could be said of the renovation of Porches. But there are some differences. Bruner went on to note that his firm's "art is successful because our hand is invisible. The apparent naturalism and seeming absence of self-conscious 'design' were in fact carefully worked out and deliberate." The transformation of worker housing into a contemporary hotel, on the other hand, actually required more "design." The River Street houses' make-over required an architectural firm where experience in the renovation of older houses was important. Williamstown architects Ann McCallum and F. Andrus

Burr seized upon the symbiosis of the mill housing and industrial complex. Burr & McCallum have earned a reputation for understanding the local vernacular and for adaptive reuse: they have rebuilt barns, erected houses that look like barns, and designed schools, all of which are in western Massachusetts. Their understated, tradition-anchored design is handsome, often elegant, and always environmentally aware.

While their 20-year practice is focused in the Berkshires, it would be inaccurate to label Burr and McCallum as "regional designers." Canadian Ann McCallum studied in Wales, at McGill University in Montreal, and earned her architectural degree from Yale University. She worked for Rafael Viñoly in New York and was the 1989 winner of the Andrea Palladio Award. Andy Burr is from the Hampshire County village of Worthington; he graduated from Williams College and received his professional training at Yale. Burr worked for the mega-firm of Kohn Pedersen Fox in New York and was partners with Yale classmate Peter Rose in Montreal.

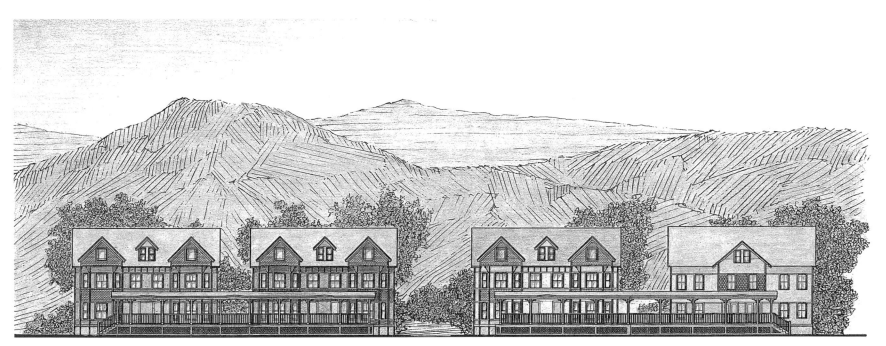

South elevation, exterior color study, pencil sketch on paper, Burr & McCallum, 2000.

The Yale connection is significant, especially for Burr who was there during the heady days of the late 1960s and early 1970s when the School of Art & Architecture, under the leadership of Charles Moore, was struggling to overthrow modernism and replace it with socially responsible, vernacular-inspired design. Burr was one of the students who went to Kentucky with Moore to construct a civic center for a remote Appalachian village. Burr later built inexpensive "chain saw" houses in Quebec.

Both the idealism and the unfinished lumber aesthetic stayed with Burr, while he and McCallum made a name for themselves as architects willing to work with existing, and often less glamorous, more utilitarian, structures such as schools and barns. Burr and McCallum converted a former grocery store into office space; their renovation of a large barn won critical praise from *The New York Times*. Even their new construction borrows from the best of the Berkshires' no-nonsense farmhouse-and-barn tradition.

Perhaps the most remarkable work of Burr and McCallum is a small manufactured house – essentially a vertically stacked "double-wide" trailer. This surprisingly stylish Williamstown house was ordered from a factory: the house's modules are constructed of corrugated metal, the roofing is asphalt composition, and the windows are off-the-shelf. Pipe-and-wire railings and catwalks make reference to similar elements at nearby factories, while there are echoes of "American Gothic" wooden farmhouses.

By combining inexpensive industrial techniques and informed aesthetics, the stacked house (lauded as "small and smart" by the Viennese journal *Architektur/Aktuell*) demonstrates why Ann McCallum and Andy Burr were the right architects to tackle the transformation of the River Street houses into Porches. Ideally, the hotel needed the same "hip" appeal as the contemporary art shown at MASS MoCA, but it also demanded respect for the spirit of the workers who had toiled in the mill.

That respect is manifested by the degree to which the fundamental structures are left intact: each building became part of the hotel, with only the continuous 142-foot front porch joining them. Over 50 hotel rooms, suites, and lofts were ingeniously fitted into what had been the two-apartments-down/two-apartments-up configuration of the houses. The placement of different room types is naturally more varied, but the architects retained the original hallways with their steep stairs. The space between the parallel rear wings was covered with skylights and spanned by catwalks.

The unifying function of the front porch has been accentuated by painting it a dark red and gray. The individual identity of each house is maintained by coloring each differently: red, sage, yellow, gray, and blue. The Stick Style trim members are the same dark red contrasting color. This Victorian row does not approach the over-the-top gaudiness of San Francisco's Painted Ladies, yet even in its rather muted New England dress is not without a touch of sauciness.

When one thinks of features at new hotels – Michael Graves' giant swans at Disney World, the glass elevators of an in-town convention center, or even the boutique hotels that began changing the market in the 1990s – it was clear that the project deserved something with local integrity. The hotel had to be in the context of North Adams' history, it had to speak to the past of the River Street houses, but it also had to acknowledge and respond to the presence of the museum just across the Hoosic River.

How do you decorate the walls in a building across from an art museum? How do you create an appealing but unusual hotel without resorting to the cliché typologies of Early American or Cool Modern? Most of all, how do you pay homage to generations of families who lived here? The solution was a synthesis of retro and contemporary, a unique "industrial-granny" style that draws heavily on the 1940s and '50s. Ann McCallum's slightly European edginess and the tasteful but always eclectic and offbeat eye of Nancy Fitzpatrick (operator of Porches, as well as the owner of The Red Lion Inn of Stockbridge, Massachusetts) proved a successful combination.

Ann McCallum's studies for finishes and colors for the guest rooms

to best set off Nancy Fitzpatrick's eclectic furniture collection.

The hallways look as they did for most of the past century: dark, simple wood-work and painted floors (for people who could afford neither carpeting nor linoleum). The only original interior decorations that remain are the rosettes at the corners of the doors and windows. The walls are now adorned with tourist plates. But this reference to the past is done lovingly; there are no notes of condescension, no camp for its own sake, and many of these artifacts refer to the Mohawk Trail, which ends in Williamstown.

The chrome, aluminum, and slate bathrooms would not be out of place in a swank hotel in Helsinki or Zurich, but there are also paint-by-number pictures, patchwork coverlets, and two-tiered lampshades from the '50s. The architects designed new furniture for Porches: steel chairs and cupboards that recall mill lockers. Each of the rooms is different, and there are elements of surprise throughout, but all have the flavor of a visit to one's great aunt Mimi, a retired librarian who was reputed to be the inspiration for Marcel Duchamp's *Nude Descending a Staircase*.

There is an undeniable irony in developing a high-end hotel in the space once occupied by workers. Worker housing may be chic, but hard to explain to people who left town when the mills closed and who would need a week's wages to pay for a night at Porches. But, try as we might, the past cannot be recreated or even recaptured: the architects and developers have maintained the presence of the old houses, with respect and without mawkishness. Yet Porches was key to Jack Wadsworth's inspired vision for a North Adams renaissance. Good things engender more good, and the ripple effect of Porches' high stan-dards will mean new restaurants and businesses, whereas a chain motel would have contributed almost nothing. The tragic lessons of urban renewal seem to have been heeded here. In short, MASS MoCA and Porches represent North Adams' next generation.

Having created the country's largest museum for the display of contemporary art, having literally enlisted art to rescue a city, and having fashioned a hotel from derelict tenements, what do you do for an encore? One answer lies in a new building that Ann McCallum and Andy Burr have designed for Porches — a fit-ness center and pub, to be built on the site of the old Stone Mill on River Street.

The architects want their work to convey the sentiment that North Adams can be proud of the beauty of its mills. With a sawtooth silhouette echoing the skylights of some mills, a twenty-foot-deep porch, and all-steel factory sash, this spa will be a tribute to North Adams' industrial past. Much of the sash will be without glass, however, for this will evoke a 19th-century factory, a piece of collective memory for the city.

This composition marks a turning point for the museum, the hotel, and for North Adams, for this expansion of Porches will not just be about the past. The spirit behind renovating the Arnold Print Works into MASS MoCA has blos-somed into being something more than just about survival. That spirit is about creating a future worth preserving.

PORCHES

Life on River Street

BY JOE MANNING

Less than half a mile from Main Street, the north and south branches of the Hoosic River converge, defining the focal point of commercial life in North Adams since the late 18th century. Shortly after the Civil War, industrial development at the confluence of the Hoosic culminated with the construction of Arnold Print Works, a cloth-printing company that would become internationally successful, employing over 4,000 mill workers. By the beginning of the 20th century, Arnold Print Works had erected several dozen brick mill buildings that stretched for over 1,000 feet along the south bank of the river.

Across the river, in the shadow of Arnold Print Works' iconic clock tower, River Street emerged as one of the city's most well-defined working-class neighborhoods. From the Eagle Street bridge west to the Brown Street bridge, mill workers and laborers made their homes in rows of tenements and multi-family Victorian-style houses, including those that were to become The Porches Inn. Shaped by long hours of repetitive and often dangerous work, hard New England winters, and the ever-present threat of rising flood waters, the lives of most of the mill workers were a daily struggle for security, comfort, and a modicum of dignity.

On November 2, 1927, a strange darkness settled into the afternoon just as River Street residents would have been picking up their daily copies of *The North Adams Transcript*. An ad for The Boston Store on page three of that edition said, "It's Time to Think of Christmas Gifts." The popular Main Street department store was offering stylish raccoon coats for $295, misses' coats for $25, and ashtray sets for a dollar. Another ad, this one for the Richmond Theatre, announced the

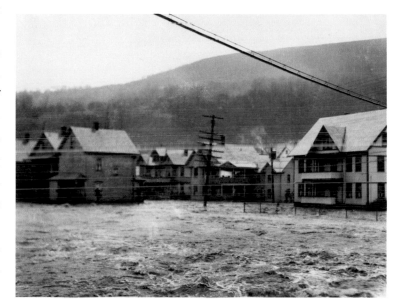

River Street, November 5, 1927, Photograph courtesy *The North Adams Transcript*

last showing that night of *The Devil's Saddle*, starring Ken Maynard, and the following Monday's grand opening of *Ben-Hur*, starring Ramon Navarro. The weather forecast called for rain.

Thirty-six hours later, over six inches had fallen, carrying tenement houses on the west end of River Street into the raging water. The Marshall Street bridge broke free and slammed into the Brown Street bridge, which somehow survived. The devastation along River Street was immense (one of several major floods over the next twenty years that would lead to the river's channelization by the Army Corps of Engineers in the 1950s). The late Anthony Talarico was thirteen years old when he witnessed the great flood of '27:

At the foot of Harris Street [two blocks west of Porches], there was a store. The water was so strong that it took that store and turned it around and floated it down the river. There were about three tenement blocks right after Harris Street. The water began to eat away at the first tenement block. All the people in the houses put planks from one tenement block to the other and crossed over to the center of the middle tenement. The fire department came over and put a ladder across River Street, which was like a rushing torrent. People were screaming. I can still hear it.

A mile to the east of where Porches is today, in the Willow Dell section near the Barber Leather mill, a tenement occupied by Arthur and Rosanna Robert and their three children slid into the river, carrying everything they owned with it. For a short time, the family was scattered around in various apartments, until Mrs. Robert's boss, H.W. Clark of the Clark Biscuit Company, found them an apartment at 223 River Street.

Their daughter, now Annette Duprat, was born nine years later. After growing up in the River Street house, she married Vincent Duprat in 1956, who was a printer at Excelsior Printing Company. Later they started their own business in North Adams called Beck's Printing, which they sold in 1995. Annette has fond memories of living on River Street:

Our apartment was downstairs. It had three bedrooms, a large kitchen, a dining room, a parlor — that's what we used to call it — and a pantry. There was a coal stove in the kitchen and one in the dining room. My grandmother lived with us. I slept on the couch until I was twelve years old. She died, and that's when I got a bedroom. I went to Notre Dame School. It took about twenty minutes to walk it. In the winter it was bad, believe me. In the morning, my mother would have my shoes heating up in the stove. We'd go up River Street and Holden Street and Lincoln Street, and that would take you on Center Street and Eagle Street, and then up East Main. At lunchtime, it was 20 minutes back home, 20 minutes to eat, and 20 minutes back to school.

We played in the backyard: hide and go seek, tag, alleys, nipsy, all the games the kids don't know today. We used to go up on the sand bank behind our house, get on the top, and roll down in the grass. We used to sit on the porch and talk at night and watch the cars go by. There were a lot of people walking by, too. You could hear the river running in the spring. You really couldn't see too much across the street, just Sprague's and the Studebaker garage.

When I was growing up, people would say to me, 'Where do you live?' And I'd say, 'River Street, in between Houghton and Veazie.' I didn't want anyone to think I lived down at River Street extension. That area had a bad reputation. But I had friends from school that lived down there, and I thought they were about the same as us. Not everyone was poor.

I remember there were three brothers who used to sleep behind the billboards on River Street. When I was going to school, and even when I was working and coming home at night, I used to run down the street to my house, because I was afraid someone was behind the billboards. I guess they had no place to live. The police used to take them to the jail when it was cold, sober 'em up, and they'd come back out.

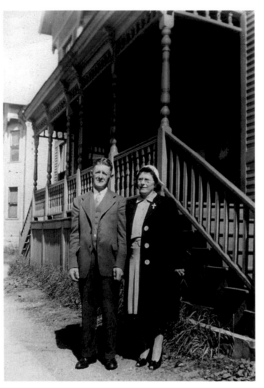

Annette Duprat's mother and father, Arthur and Rosanna Robert, circa 1948.

There were a lot of little grocery stores around. Everybody knew their neighbors, not like today where you don't even know who's living next door. My father died there about 20 years ago when he was 87 years old. My mother wound up living on River Street 55 years.

John R. Flaherty was six years old and living on the first floor at 231 River Street when his mother hurried him up the hill to his cousin's house on Veazie Street to escape the '27 flood. When the water got up to the porch, his father was working the night shift at Noel's Restaurant downtown on Main Street. John and Mabel Flaherty had moved from Charles Street in the west end of the city to River Street in 1924 because they didn't have a car and it was close to downtown.

After a stint as a short-order cook at Noel's, his father joined the North Adams Police Department and eventually became one of its most popular police chiefs. He retired in 1965 to serve as the relocation officer for the city's re-development authority during the south side urban renewal project. He died on his wife's birthday in 1987.

Son John graduated from St. Michael's College and served in the Navy from 1943 to 1946. A retired optometrist, he is 80 years old and still lives with his wife Helen in one of the city's newer neighborhoods on the east side. They built their house in 1964. Like Annette Duprat, John enjoyed his younger days on River Street:

When we moved in, the house wasn't wired. We had no electricity, but we got it soon after. I can remember all the trips down to the cellar replacing fuses. There was only one circuit for the whole apartment. They had an oil-burning range in the kitchen and one in the parlor. I remember that jug of kerosene. My mother didn't like it. They finally hired a contractor to put a furnace in for central heat. Their apartment was the only one that had that. It cost them a fortune for oil, because there wasn't any insulation. The bedrooms were still cold.

There used to be a culvert that came out in the river near Veazie Street. I can remember going down there and catching minnows. That was before the flood chutes. We had a little baseball diamond on that empty lot on Houghton Street. We went right up from our back door to the sand bank. I remember doing stunts up there like jumping off the bank into the sand. No mischief though. When your father's a policeman, you got to behave.

We used to play a lot of card games on the porch together, like cribbage. There was a rail on the porch between the two tenements, and people would sit on both sides. There was a meat market called Van Steemburg's that faced the Brown Street bridge. I remember my mother giving me a quarter to go and get a pound of hamburg.

We could walk to everything: shopping, work, church. My father bought his first car in the 1930s. It was a Model A Ford. That was a big treat, because we went on fishing trips. We did a lot of things together as a family, like blueberry picking. We were kind of poor when we were kids. We didn't have much. We had the basic things. I was happy. We had a plain, simple life.

By the 1970s, the quality of life in the city and especially on River Street was declining steadily. At Sprague Electric Company across the river, layoffs became common headlines in *The North Adams Transcript*, and businesses and buildings on Main Street were disappearing under the pressures of a dying economy and the rubble created by federal urban renewal grants. One by one, the Victorian mill houses on River Street were sold by aging owners to landlords who appeared to have no interest in maintaining them. John Flaherty saw his parents' neighborhood crumble around them.

It was awful. I was a little bit ashamed of it. I went up in the attic once and found a hole in one of the corners. Pigeons had gotten in. Pigeon droppings were all over the place. If the Board of Health ever saw it, they would've shut the place right down. My mother knew that, but she wouldn't move.

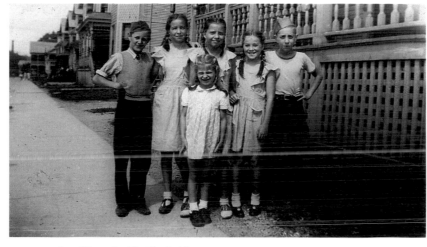

Annette is little girl in front middle, her brother Art at far left, circa 1942

They had a lot of tenants that would come and go, probably the ones that didn't pay their rent. After my father died, my mother still kept her apartment up, and it was the only decent place there. People would always be asking me, 'Does your mother still live down there.' And I'd say, 'She likes it there, she's happy.'

Finally in 1994, she couldn't live alone anymore, so she moved in with us. She had been there 70 years. They were the longest tenants there to the best of my knowledge. She hated to leave. She always had a favorite chair in the parlor by the big front window. At our house, she'd complain, 'I can't look out the window and see all the people going by.' She died in a nursing home in 1997.

After Mabel Flaherty moved out in 1994, the neighborhood continued to erode. According to Michael Sarkis, Director of Public Health for the City of North Adams, an agent for the Board of Health:

Neighbors would constantly call with complaints about broken glass and garbage. There was trash and debris, stained walls, rodent infestation for lack of doors being closed, dog and cat feces on the floors and carpets, and kitty litter boxes that hadn't been dumped in weeks. You never knew what you were walking into there.

Everything was repaired under the minimum standards. If we told the landlord to put a screen in the window, he'd go get a roll of screen, cut a piece, and staple it to the window. The people that the landlords hired were not professional carpenters. They were willing to work for under $10 an hour.

Many of the tenants would stay for only a few months, make a mess, then leave without paying the rent. Cabinets would be ripped off the walls. There were lice, fleas, and cockroaches. Some people would take the trash out to the back porch and toss it off.

One time a tenant called to complain about the landlord. She was upset because she couldn't put her silverware in her drawer because of mice droppings. When I opened the door, the aroma was terrible. I had a pair of loafers on. As I went into the kitchen, I walked right out of my shoes, because they were stuck to the floor. The place was unfit for human habitation.

Filled with the memories of working-class families, these mill houses in early 1999 appeared destined for demolition. Several showed the sagging roofs and tipping foundations that signal the end of a building. In less than a century, River Street residents had witnessed the prosperous years of Arnold Print Works and its decline during the Great Depression. When Pearl Harbor was attacked, sons of River Street were carried off to war on outbound trains that disappeared into the valley. A year later, River Street people saw Arnold Print Works go out and Sprague Electric come in. Sprague was to prosper for nearly four decades.

In the early 1950s, people watched from River Street windows as the Army Corps of Engineers tore up the riverbanks and installed the flood control chutes. In 1986, all went quiet as Sprague closed. For those who still remembered the old days, the river no longer raged, the clock tower no longer rang, and the trains seldom whistled in the night.

River Street became the home of a soup kitchen and the Salvation Army. Front doors lay open in tenements and houses, exposing baby carriages and beat-up bicycles under stairwells. Sheets of clear plastic covered windows, and young men smoked cigarettes and worked on junky cars.

Across the river, the renovation and conversion of Sprague Electric into MASS MoCA began in 1995. Windows were duplicated and replaced, paint of matching colors was applied, and brick walls were restored slowly. But on the old houses, window frames continued to rot, paint continued to peel off, and the porches continued to sag. The River Street apartments had become infamous for their sub-human living conditions and poor upkeep. In some cases the buildings were quasi-abandoned; others were the sites of frequent police busts.

When plans for The Porches Inn were announced, the houses had the prospect of a new, if vastly different, life. Most of the remaining tenants were happy to relocate; almost anything would be better than River Street. Yet some of the tenants appreciated the size and location of the apartments, and were ambivalent or worried about the coming change. Forty-three-year-old Tina (Bushika) Holland, for example, was not happy about it. A single mother of two, she was collecting disability payments and had lived at 241 River Street for several years. Despite the area's deterioration, she enjoyed a spacious apartment and friendly neighbors:

It was a perfect location; it was close to downtown. I didn't have a car. I was on the flat; no hills or nothin'. I had a gas stove and a space heater. We had to put plastic on some of the windows, but that's a way of life around here. It was quiet. Once in a while, you'd get a bunch of drunks from the bars.

The trouble had calmed down over the years. In the middle '70s, you couldn't walk that area of River Street without a knife on you or two big guys with you. For women, it was not too cool.

But when I was living there, everybody looked out for everybody. It was like, 'Hey, I need enough to make a pot of coffee.' And they'd say, 'Sure, c'mon on over and get it.' If somebody needed something, all they had to do was pick up the phone or knock on the door. If they found out I was doin' without, I basically got read the riot act. Of course, there was a few of the other kind; you know, 'Don't know him, don't like the looks of him, we won't go there.'

The only thing I didn't like was that you'd go to sit on your porch, and you'd see that damn mill. Day in and day out, that gets to be depressing. Everybody looked at me like I was an idiot, because when I first moved in, I moved my table over by the window where I could look out at that big rock. It was better than lookin' at that mill.

Around Christmas 1999, I heard rumors that the landlord was selling. He showed up at the house one night, and I looked him dead in the eye and said, 'I heard you're sellin'.' He said, 'Nope, and you ain't gotta worry about it.' Two days later, it was in the paper that he sold it. It ended up that the landlord locked me out. He allowed me just enough time to grab enough stuff to get me by for a few days.

In the meantime, I got hold of MASS MoCA and spoke to one of the higher-up guys and told him, 'I need to get in there for the simple fact that it's gonna be overrun with roaches. I have five coolers of meat in there, plus my big freezer is half full.' He was very nice. He got me back in, but I had to throw out all the food. Then I found this place on Union Street. I went from six really good-sized rooms and an attic to four small rooms and no storage. It'll do till I find somethin' else. If I could, I'd go back to River Street in a heartbeat.

Several months after The Porches Inn opened in the summer of 2001, 69-year-old Mary Gaudreau went over with her son to take a look. It was an emotional

journey for her. As a little girl, she used to visit her aunt and uncle, Ceil and Alfred (Chick) Cardinal, at 225 River Street, which was next door to the apartment where her longtime friend Annette Duprat grew up:

There's a garage that's still over there. My son said, 'I bought my first car in 1962, and it was in that garage. I paid Uncle Chick $300 for it.' I told my story to the receptionist. He showed me the hotel. I don't know what I expected. I guess maybe I expected to see the dining room and the kitchen. They've done a wonderful job. They kept the wood around the mirrors. But they took all the memories out. I wanted it to stay like it was.

Aunt Ceil always made a lot of Christmas cookies. She used to have the most gorgeous, perfect trees. When I got older, I found out that my uncle would drill a hole where there was a branch missing, and Aunt Ceil would insert a new branch that she had just cut.

I visited them once a week. In those days, you didn't stay in the room while the adults were talking. At that time, my aunt would often talk to my mother about what kind of ration stamps she had gotten: meat, butter, sugar, cheese. I remember the china closet that was set in the wall. You never sat in the living room. That was the parlor. That was for company. Their daughter, my cousin Phyllis, had this beautiful dollhouse that her uncle had made for her.

Aunt Ceil passed away in 1970, and Uncle Chick died shortly after. They took pride in their home. They would take turns with the Roberts and clean the hall and wash down the stairs every week. I can recall going by there after they were gone, and things had changed a lot. It was messy. I looked at my aunt's windows and said, 'My goodness, it's a good thing she can't see those windows now.' She was just immaculate. It was hard. To me, it was still my aunt and uncle's house.

William P. (Bill) Strange, married and living in Williamstown, also returned to see his former home during the grand opening of The Porches Inn. His parents, Paul and Virginia, moved into the apartment upstairs from the Robert family at 223 River Street in 1950, when Bill was a year old, and later moved out in 1977. His late father worked at General Electric in Pittsfield. Bill attended St. Joseph's Catholic School on Eagle Street and graduated from North Adams State College in 1972. After serving 18 years as a merchandise manager for F. W. Woolworth, he works at home as a book editor.

The grand opening of Porches was quite an experience. It was really weird seeing what they'd done. There's a railing where my bedroom window looked out into a narrow alley. It looks down into the reception area now. It's a lot fancier than when I lived there.

We had stoves in the kitchen and in the dining room. I used to have to carry these ten-gallon oil drums down to the cellar to fill 'em up, and then I had to carry 'em back upstairs. I had to do that every 12 hours in the winter. My classmates from St. Joe's couldn't believe it. Most of them lived in better neighborhoods, and they had never heard of anything like that. I remember being somewhere, and I would say, 'I gotta get home and fill those drums, or the fire will go out and my dad will have my butt.'

I have nothing but good memories about living on River Street. There were a lot of kids around. We used to have that parking lot behind Riverside Auto Body where we played baseball. At Mausert's Ice Cream Company, we'd go to the back door on our way home from school, and whatever flavor they were making that day, they had some left over, and they'd always give it to us kids.

I remember the first person I met when we moved in there. Her name was Maude. She was an old woman with white hair. She used to sit out on the porch. She loved when the kids would come out and talk to her. She was there one day, and then she wasn't. We were small, and they didn't want to tell us that she had died. Finally, my mother said, 'She's gone away.' I think she was 98.

John Flaherty also went to the grand opening of The Porches Inn:

The only part of my mother's apartment that was the same was the parlor. A long time ago, my mother had two beautiful rocking chairs on the porch. She used to leave them out at night. Finally someone stole them. It was the police chief's home, but they still took them. Those fancy rocking chairs they have on the porch now are almost identical.

I think it's great what they've done. The city might've torn down those houses otherwise. When they had the contest for a free room, I put down that my family was one of the longest tenants there. I thought it might make a difference, but I didn't win.

When the houses were being renovated, the contractor took the house number off the door and gave it to me. I've got it on my desk. It says 231. It's a nice little souvenir. Growing up on River Street was a good experience. It made me appreciate the nicer things in life I was able to acquire later.

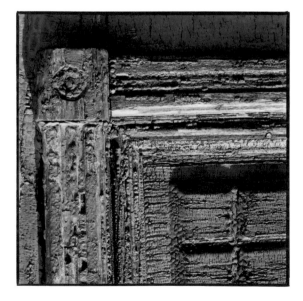

In 1974 it was my good fortune to get a summer job at the Sprague Electric Company. I worked third shift so my day began at 11:00 P.M. In the etching department where I was assigned, the machines never stopped. The lights were always on, and the hum of high voltage electricity was always in the air. We oversaw big, hot, electrically charged machines that often ran for hours unassisted. There was time to look out the oversized mill windows. The view from my window and from all the windows on the plant's long north wall was of River Street, just across the flood control shoot that contains the eviscerated north branch of the Hoosic River. On River Street stood five row houses. Though clad in asbestos or ill-fitting aluminum siding, the houses still had a detail here and there that let you know these houses had been better than average. So every day, six days a week for that entire summer, I watched those houses through the steamy early hours as the dawn slowly built until the streetlights were overcome and shut off and the sun finally came over the hill. At 7:00 A.M. it was quitting time.

Over the next 25 years much of River Street went downhill along with the plant that was linked intimately to the neighborhood. By 2002, however, with the rebirth of the former mill as MASS MoCA, River Street was in the midst of a transformation, and the row houses have been brought back from neglect to once again serve as a place of lodging for the people who occupy the plant.

I have observed and photographed the metamorphosis.

Through A Mill Window: Reclaiming River Street

BY NICHOLAS WHITMAN

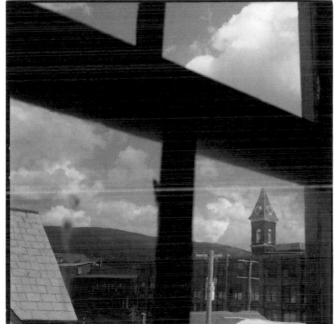

Though often neglected, thanks to the limestone foundations and slate roofs, these houses have remained mostly dry and square. They rest on massive stone foundations that stood four feet off the ground in front and protected them from the flood waters of the Hoosic River. These rampages finally caused the Army Corps of Engineers to drop the river into a 30-foot-deep concrete trench. The four identical mirrored apartments per house were built nicely with features like pocket doors, built-in cabinets, and bull's-eye molding. Most were painted, and at least one was finished with bright varnish.

I began making photographs after the tenants had left and before the demolition began. I recorded details that people had brought to the dwellings in a hundred years of living: the paint, the wallpaper, and wear marks. While in the houses, I looked out the windows and could see the mill. Out any front window from any house – there was the mill. I was struck by what a small world in which the inhabitants of these places lived. They looked out and saw the mill, walked to work and looked out at their homes. On returning home they once again looked back at the mill. Day after day until a life went by. This became a way of viewing and photographing the plant and the houses. Back and forth through the windows.

The new hotel use dictated that the interiors be mostly gutted and reconfigured, but the exterior was handled differently. As layers of siding came

off, the original shingles and clapboards came to light. The revelation of the largely intact original exterior was a high point in the renovation. In restoration, the object is stripped back to its original though damaged self. The building exists as it was one last time before again being covered and becoming the basis for something new. For several months in the summer of 2000 the five row houses stood exposed, showing their original siding and colors. Then began the rebirth.

The interiors were redesigned and brought up to code. Every surface was renewed. Utilitarian was usurped by luxuriance. The backyard was expanded. A pool and sauna were added. At the July 2001 opening, former residents marveled at the changes. Their old homes had outgrown them; they were hip, wired, cool, and pricey. In 2002, the Best Way Car Wash, Eightball Auto, and a few other businesses stood between Porches and the former plant. A rusted chain link fence topped with barbed wire rose above the walls of the flood control shoot. A section of the wall behind the car wash had fallen. The Army Corps of Engineers was looking for a better way to contain the Hoosic. Artists from as far away as Europe looked at the river as a site for installation art. The mayor wanted the businesses along the river razed for a green way. As the momentum from MASS MoCA's renovation ripples outward, it is changing the look of North Adams.

The photographs I am making of the area are a record of a unique development fueled by an art museum. Many can be considered "before" pictures. The series grows as the site evolves.

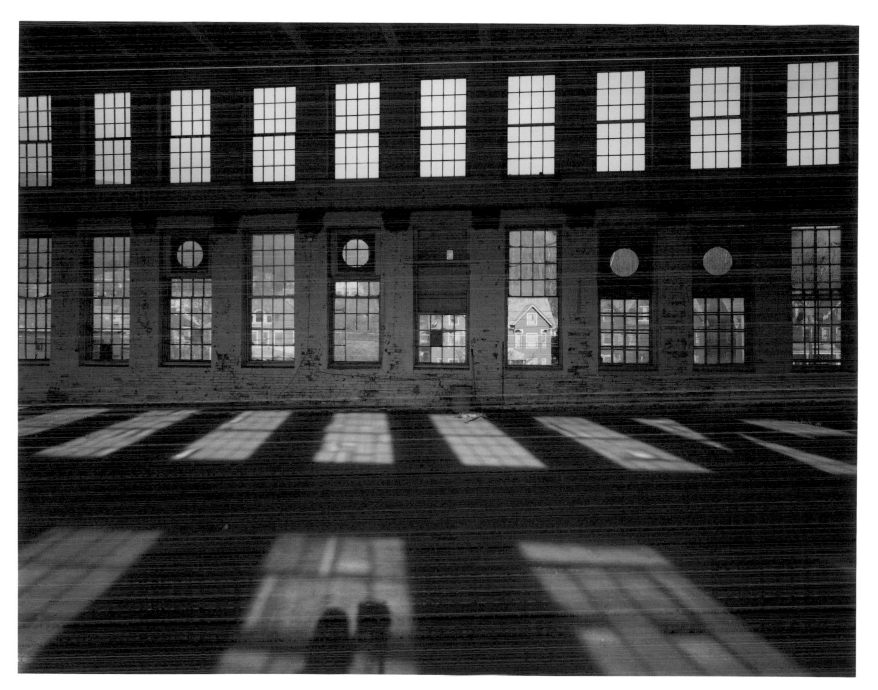

View of future Porches property from MASS MoCA Building 5 gallery

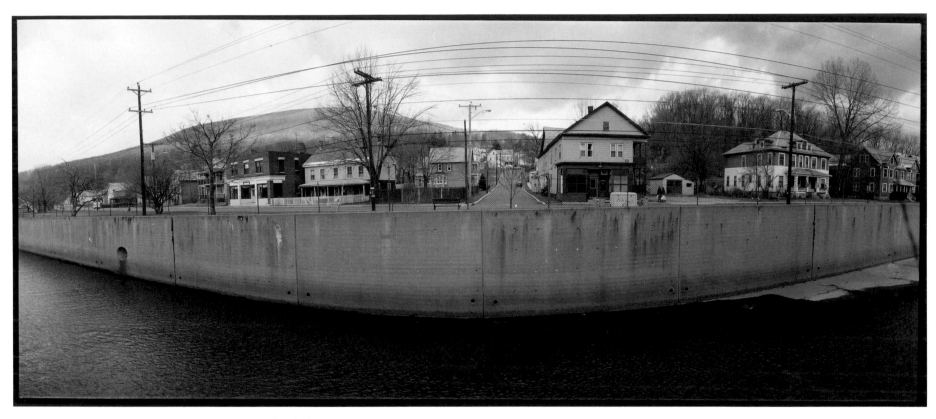

View from MASS MoCA across flood channels (future Porches properties begin on right)

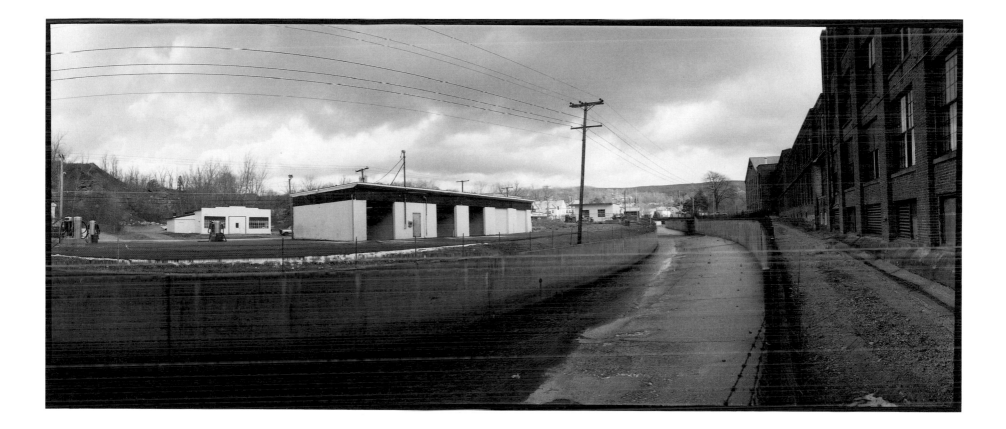

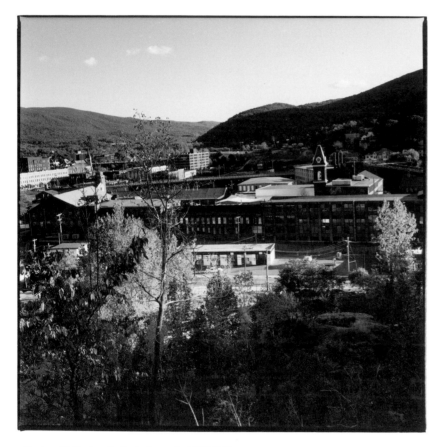

View from hillside above Porches looking south at MASS MoCA

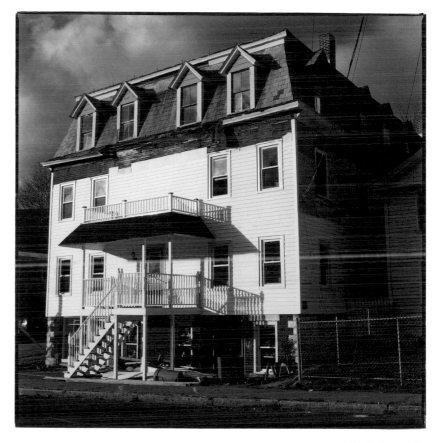

Neighboring properties

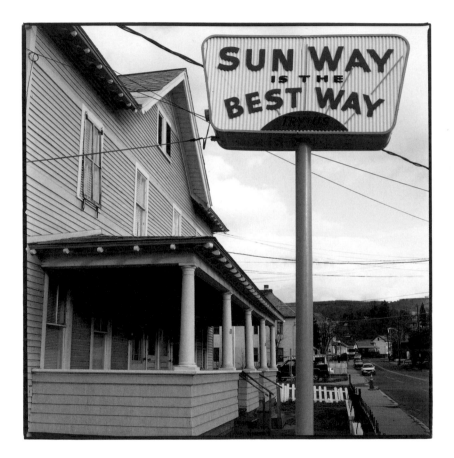

Neighboring properties

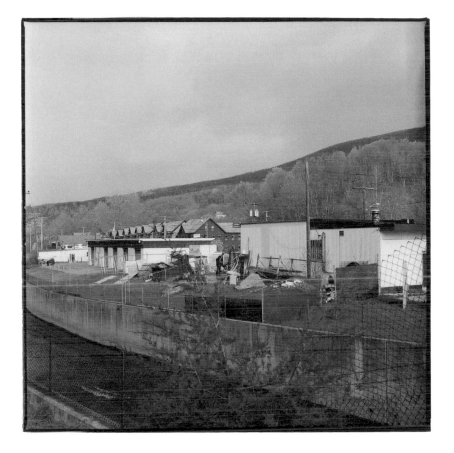 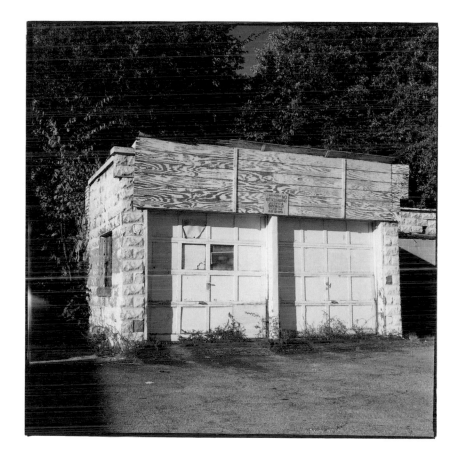

Porches building, pre-renovation

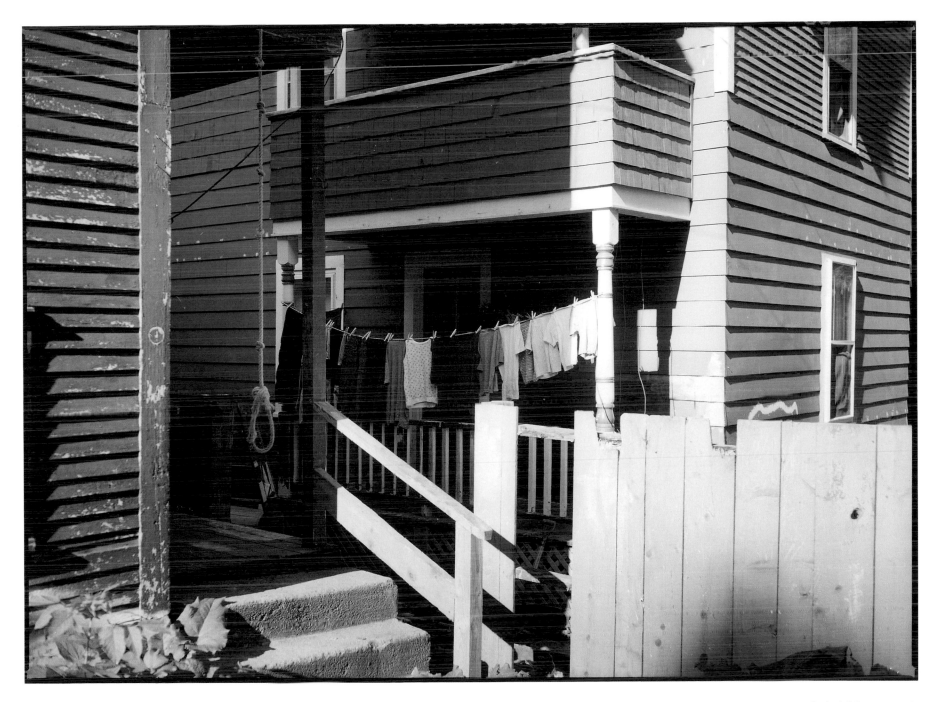

Porches building, pre-renovation

River Street

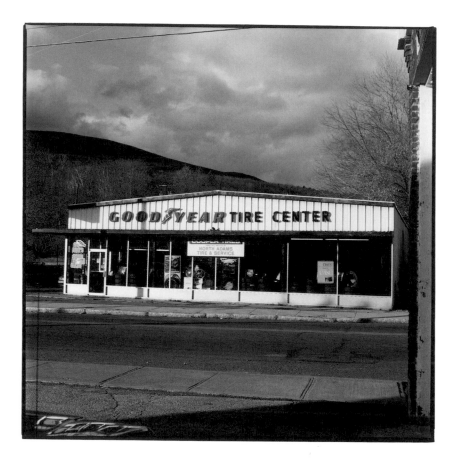

Up the street from Porches

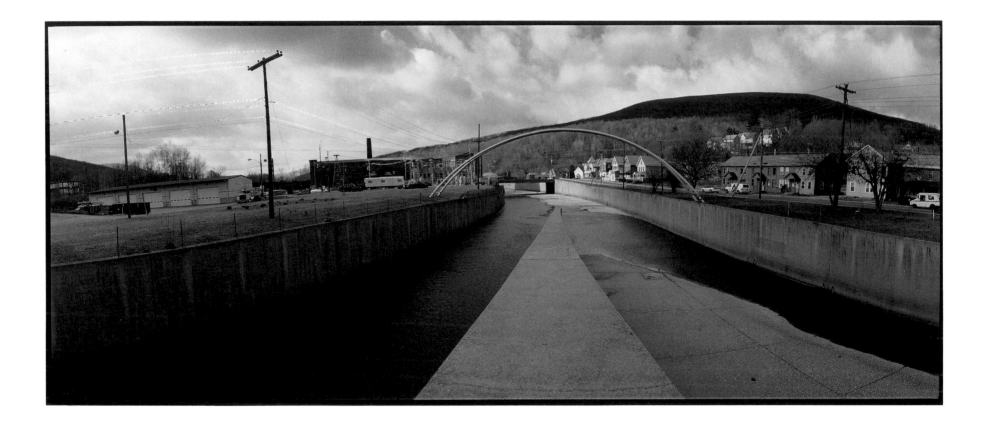

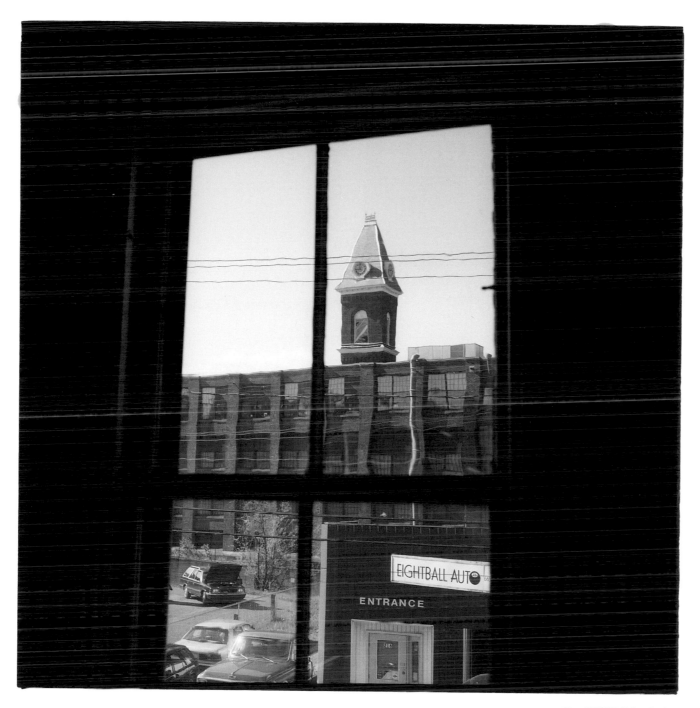

View of MASS MoCA from Porches

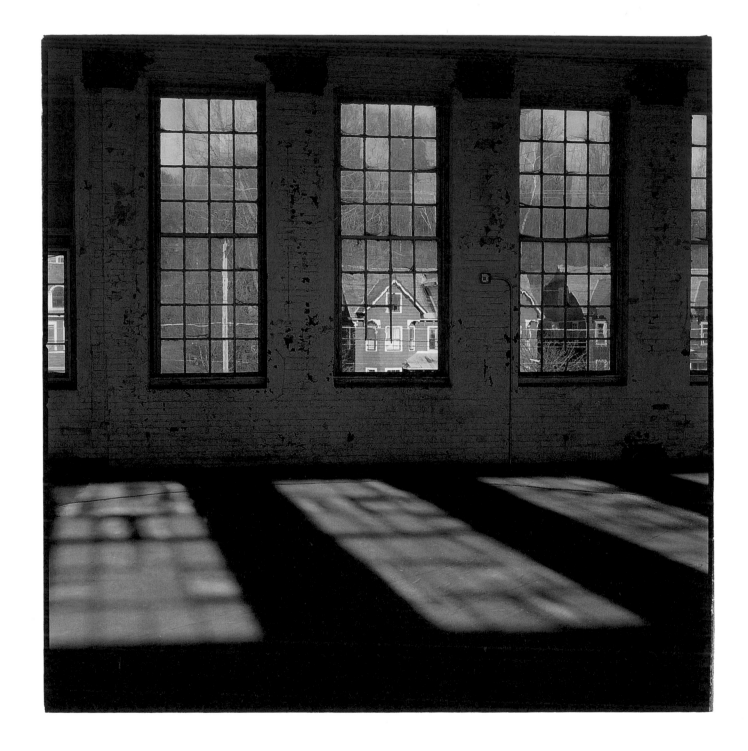

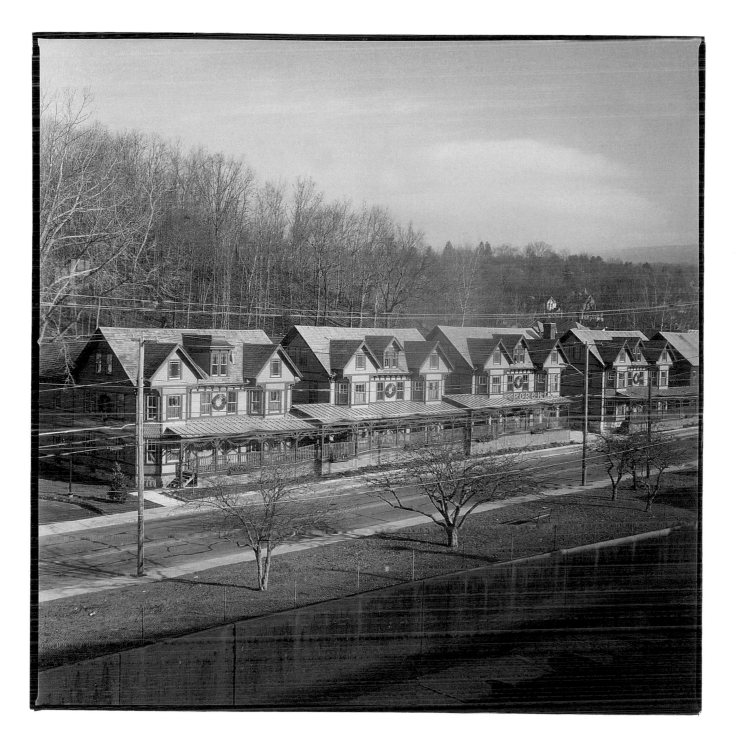

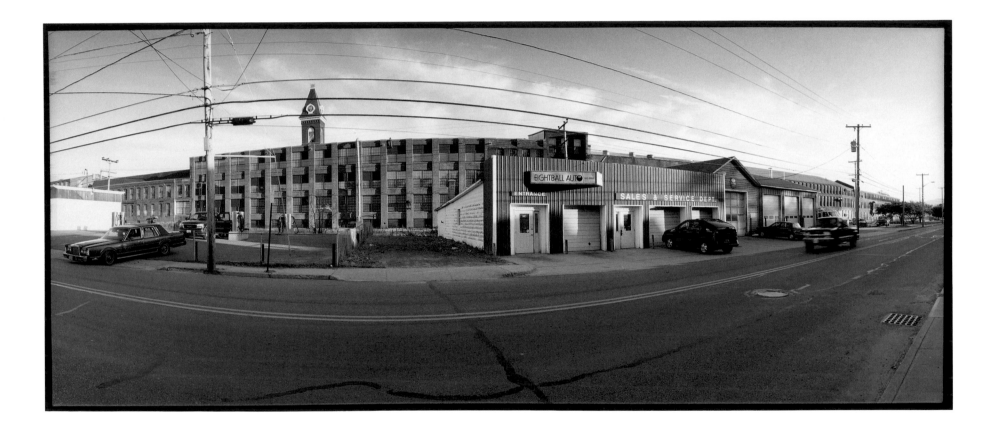

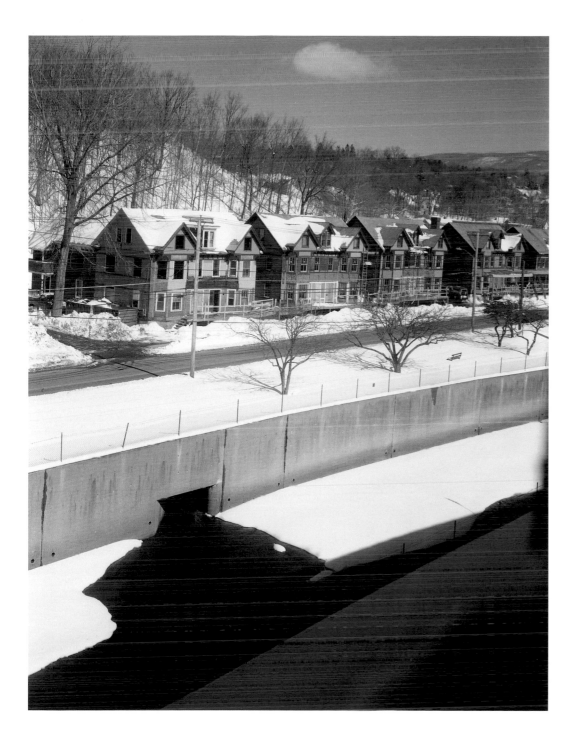

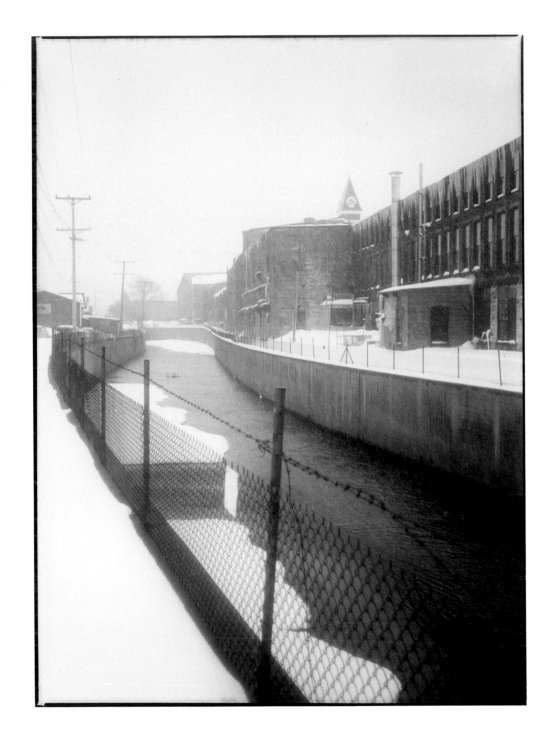

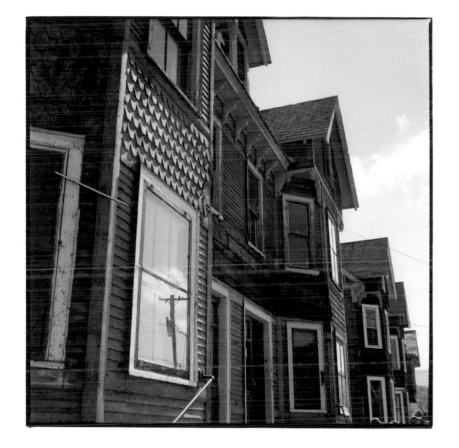

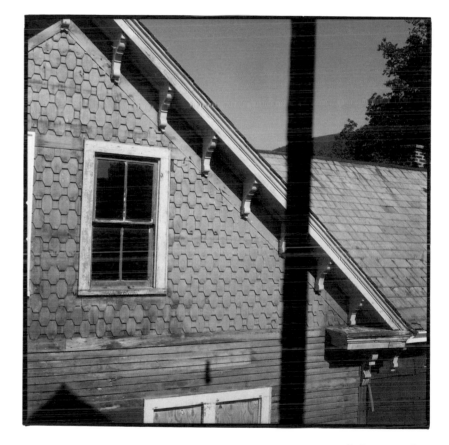

Porches pre-renovation

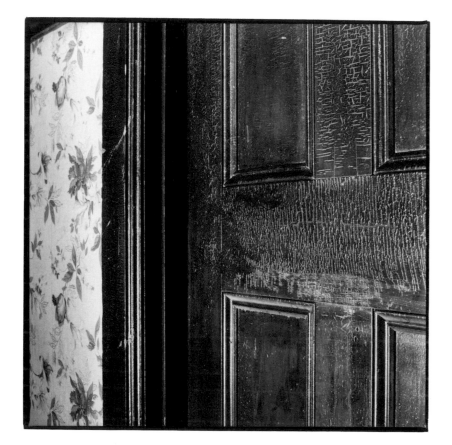
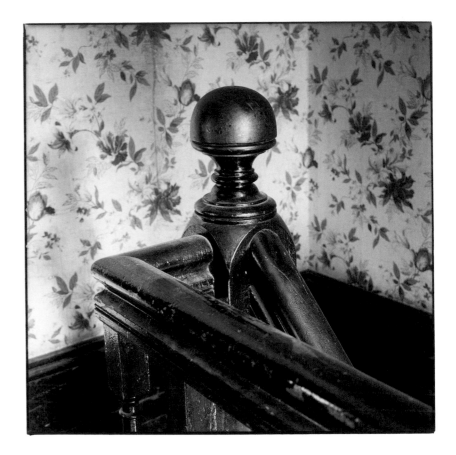

Porches, pre-renovation details

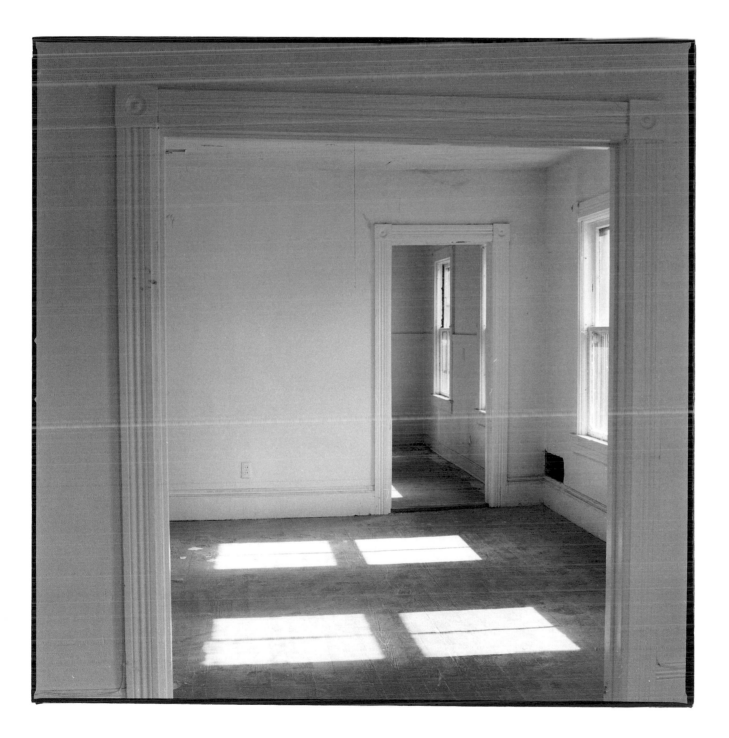

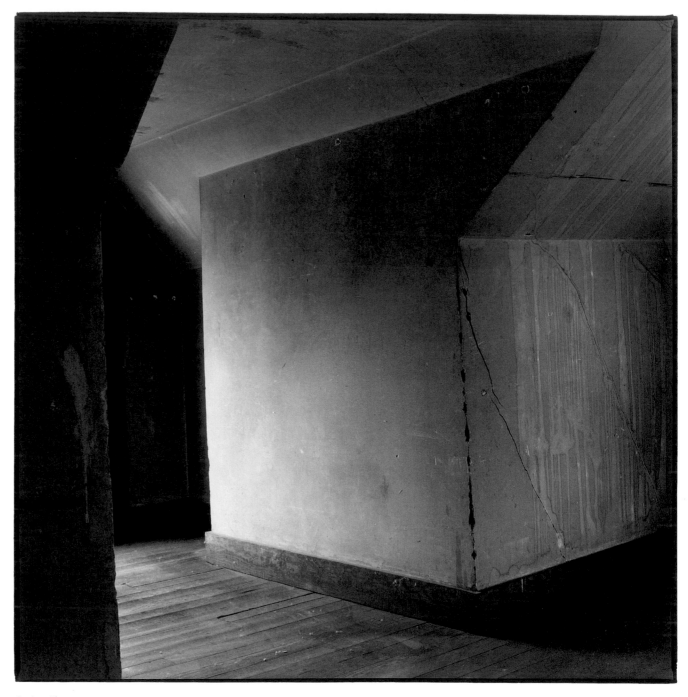

Porches attic

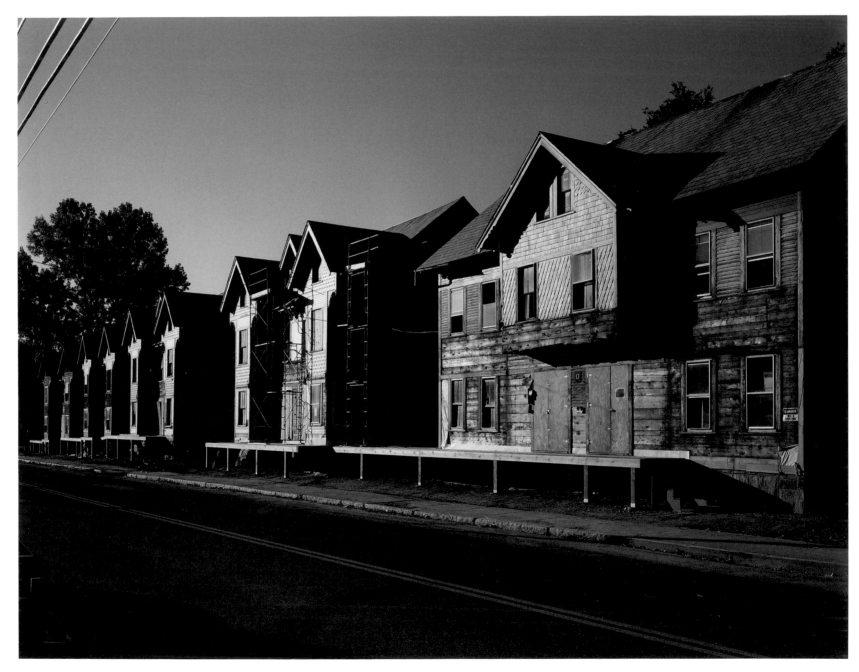

Porches during renovation

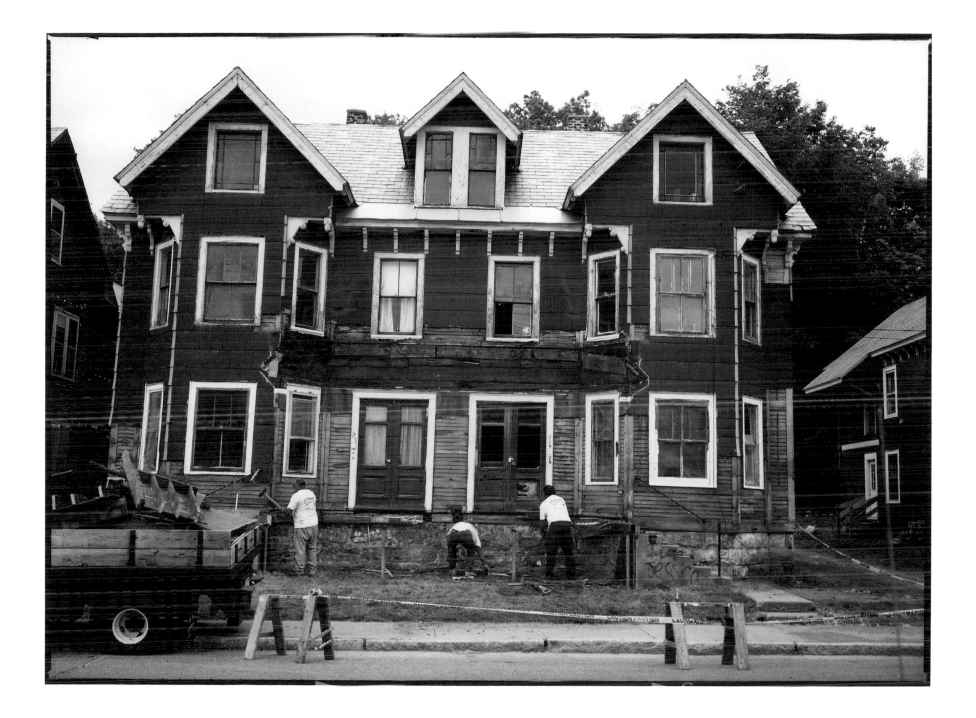

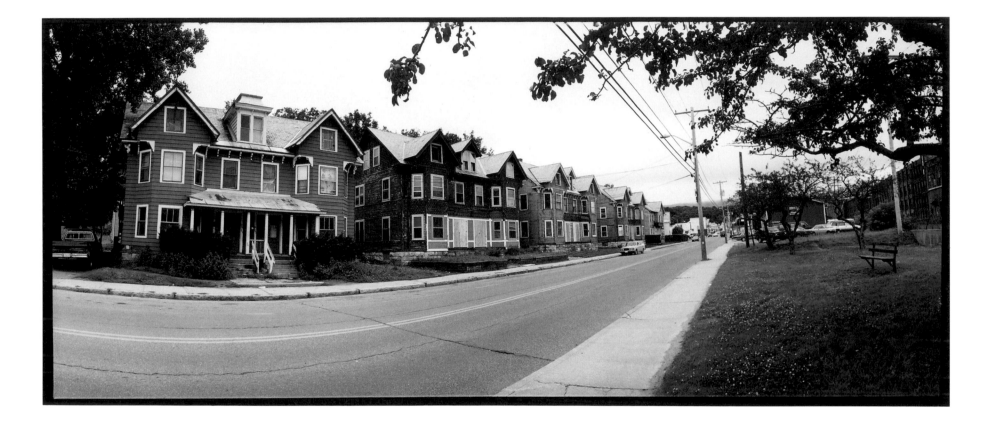

PORCHES

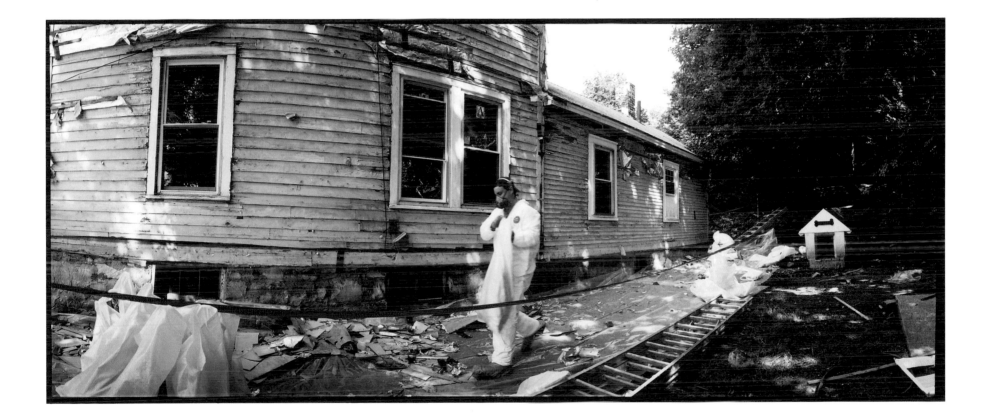

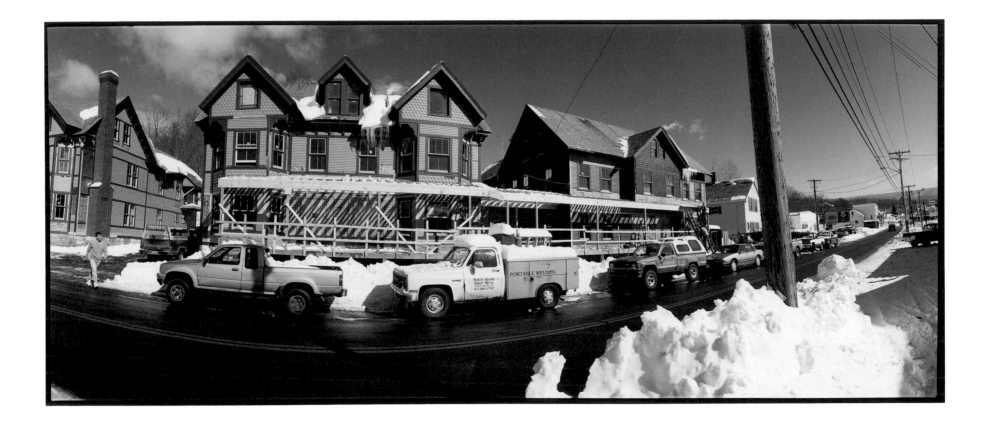

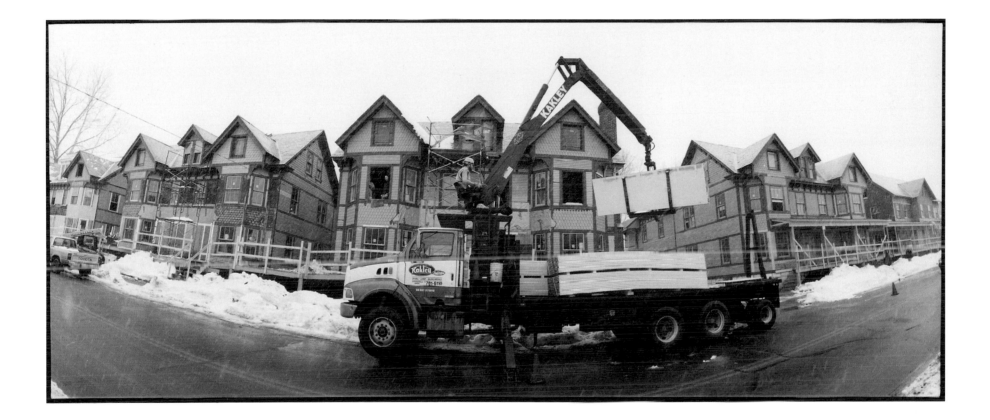

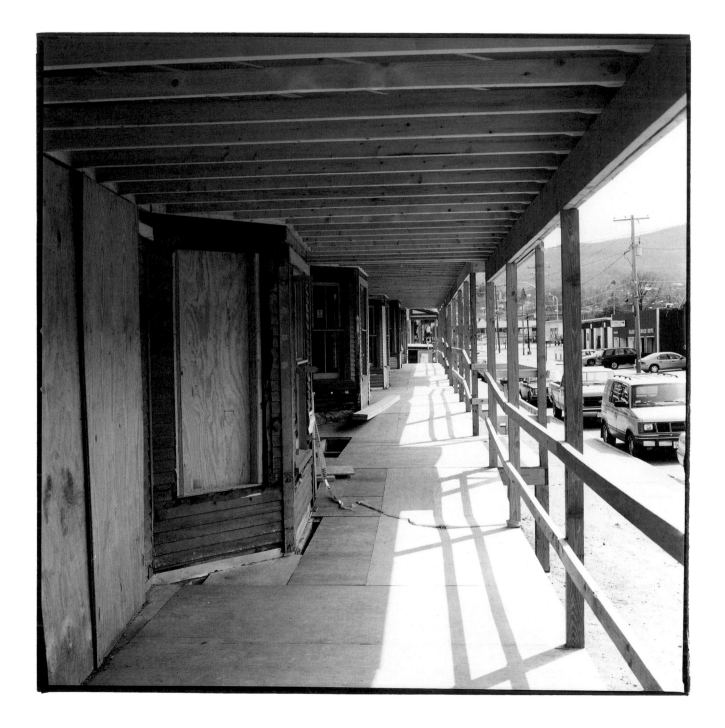

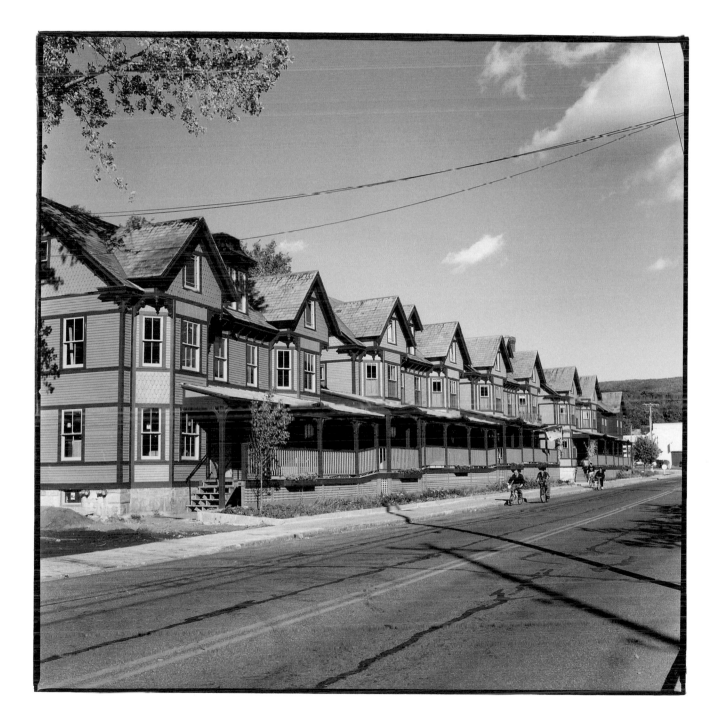

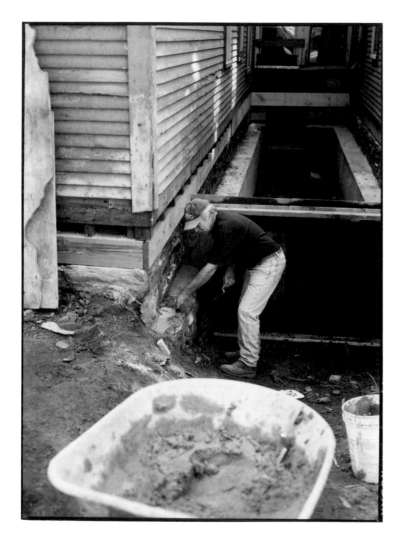

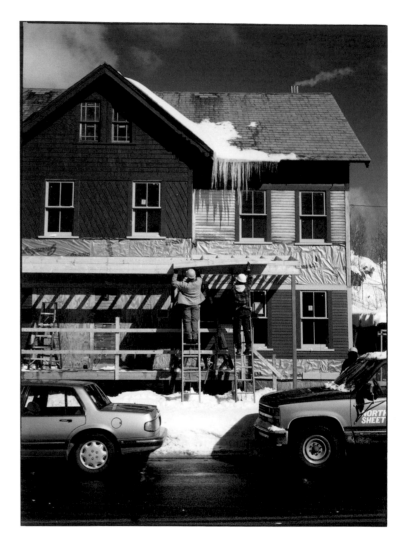

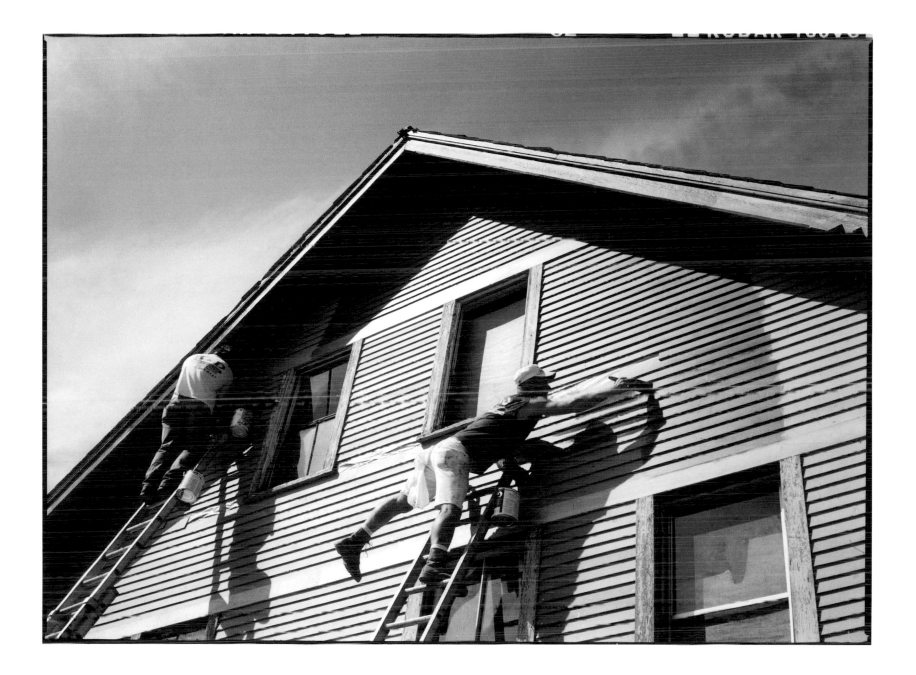

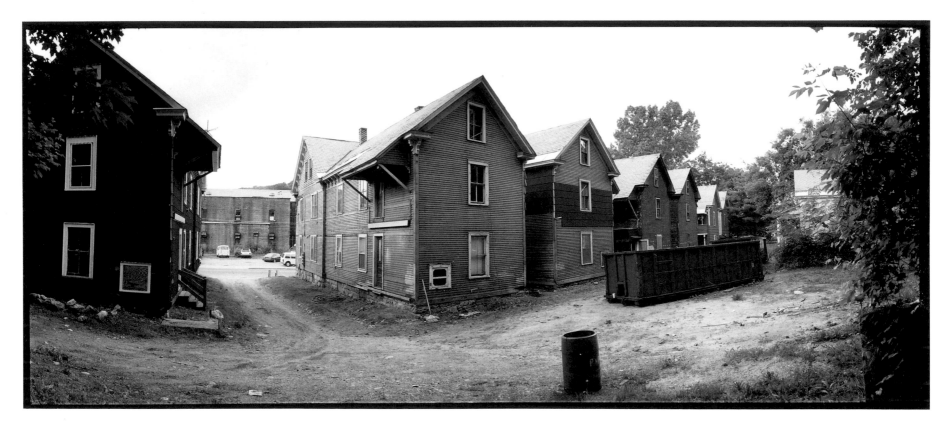

Backside of Porches during renovation

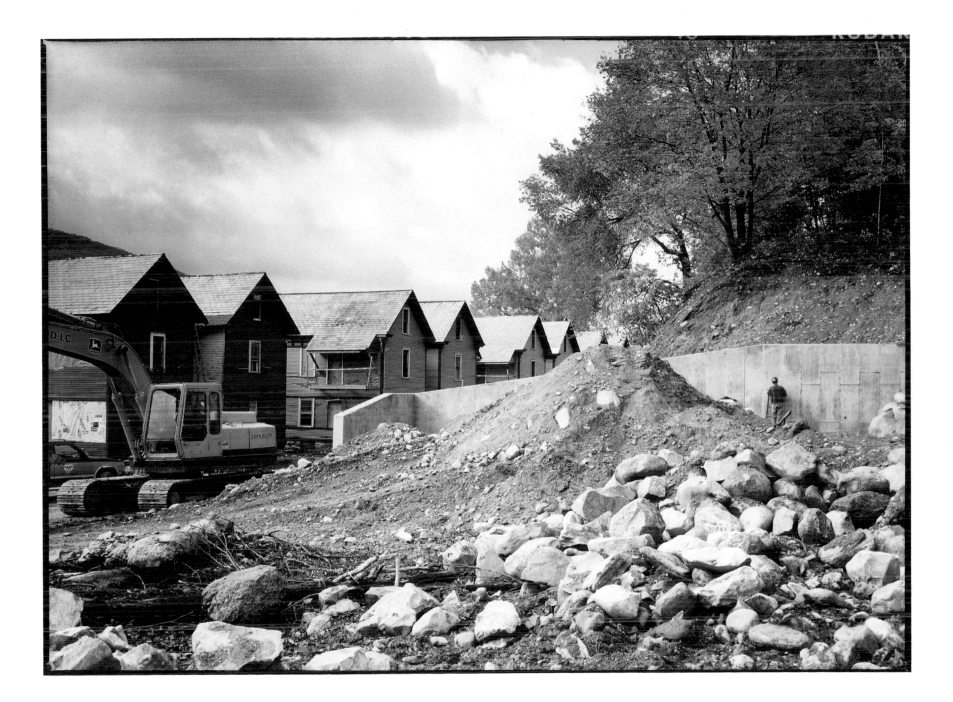

Looking south at backside of Porches

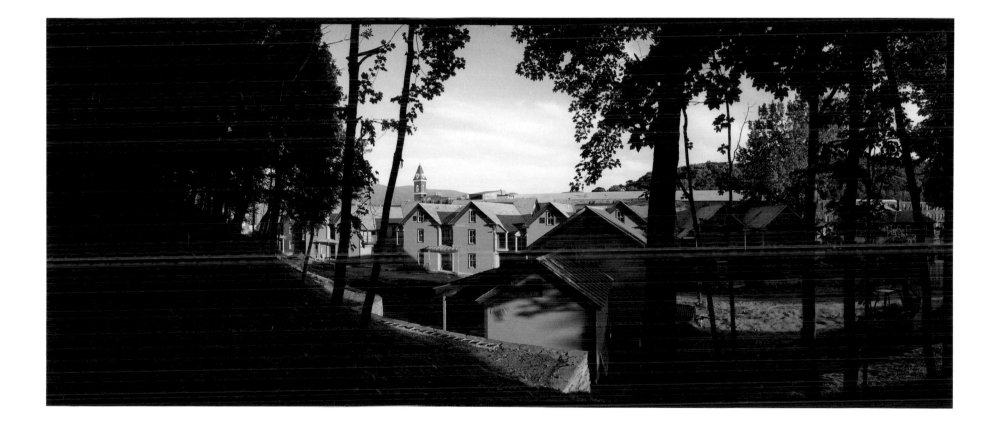

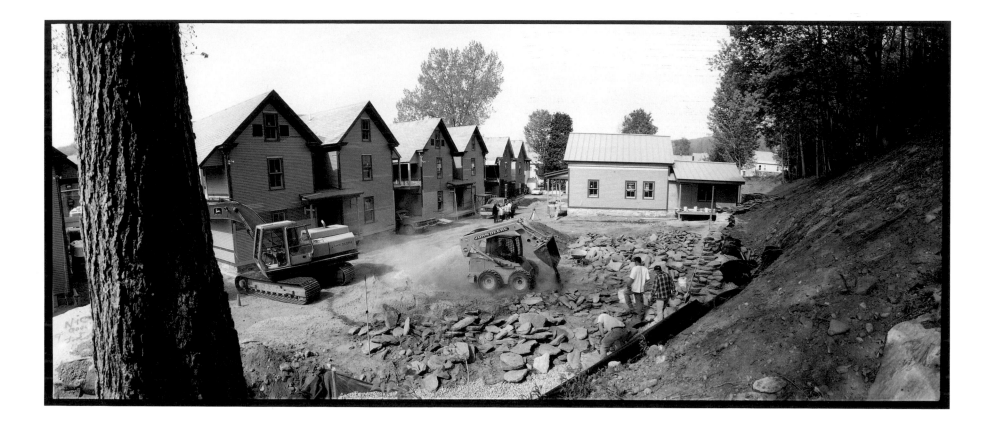

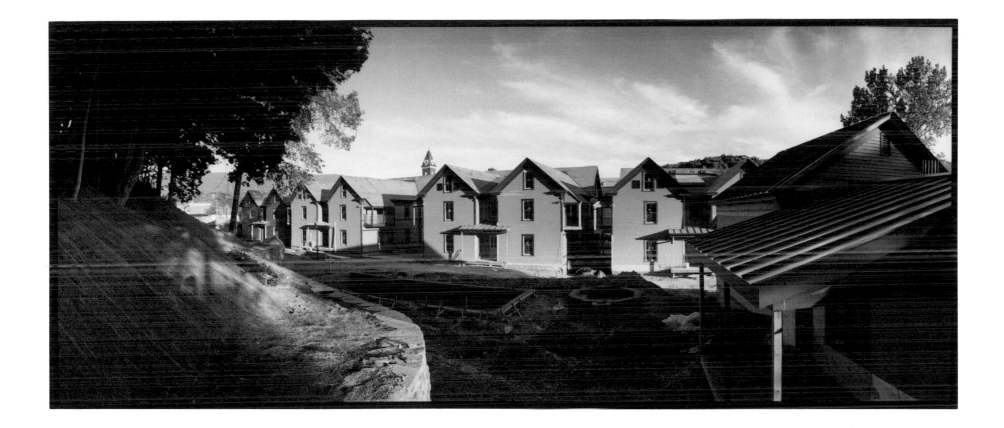

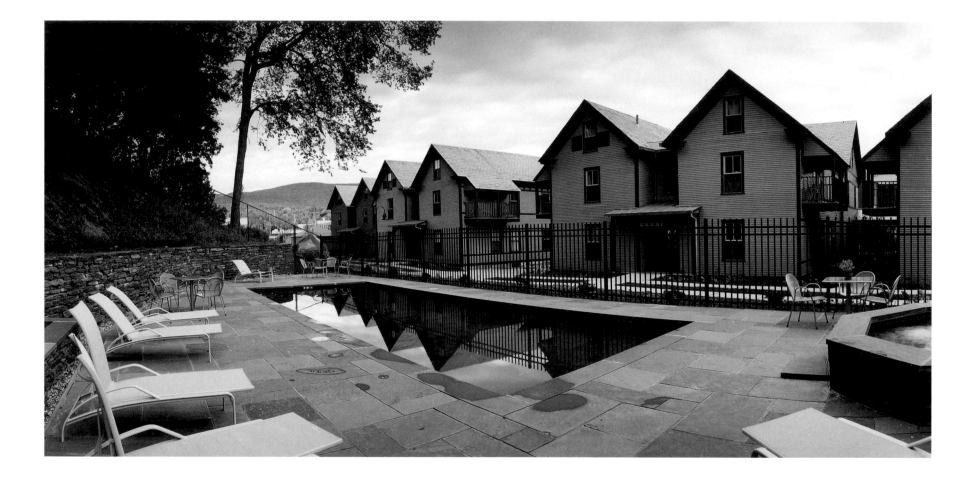

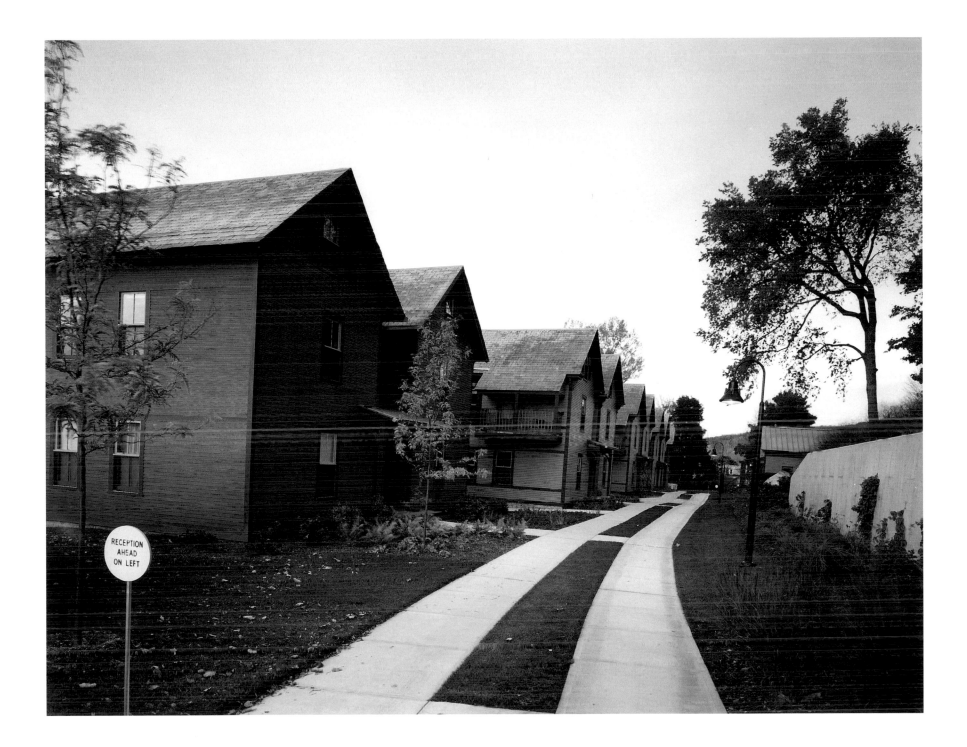

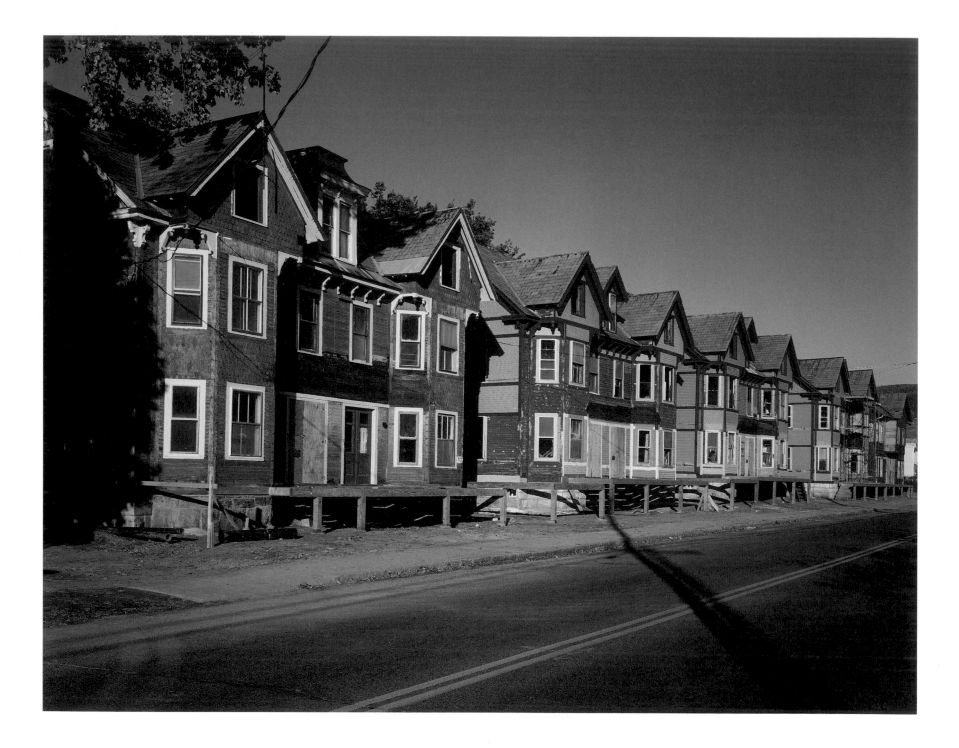

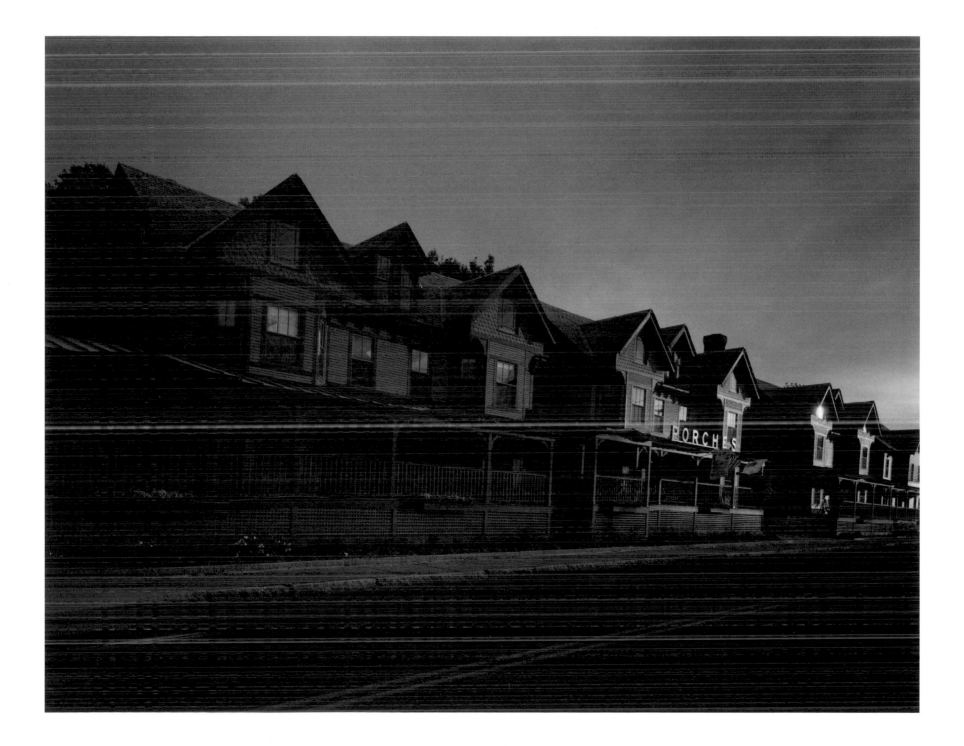

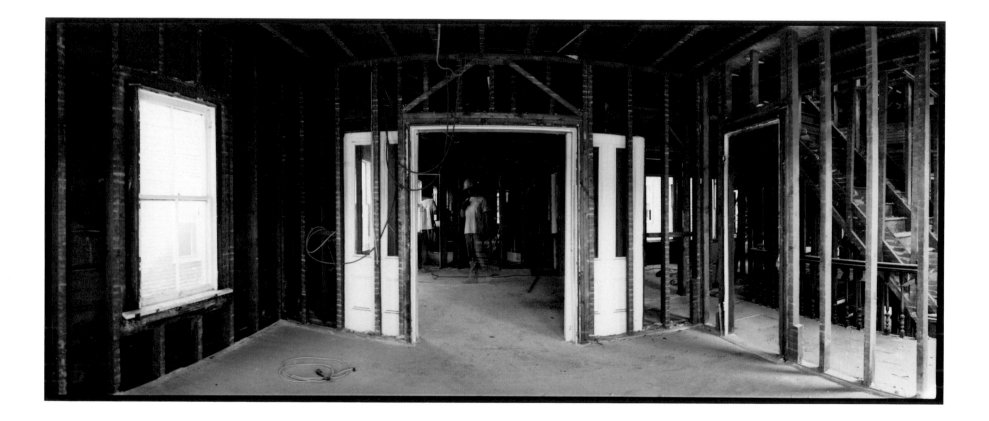

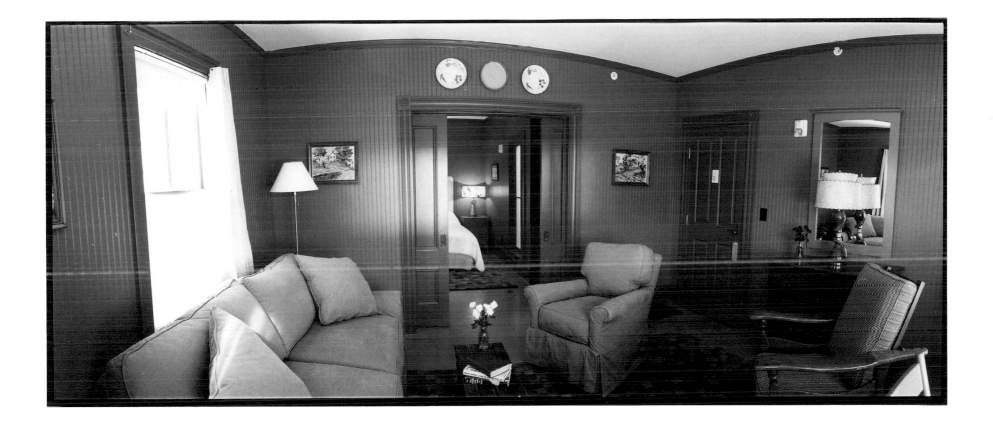

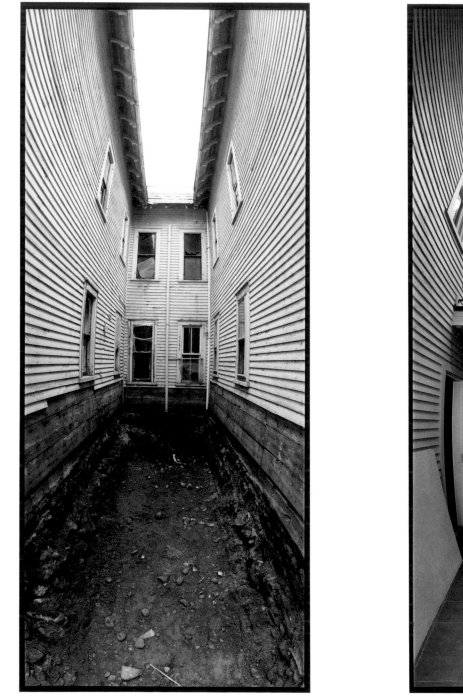
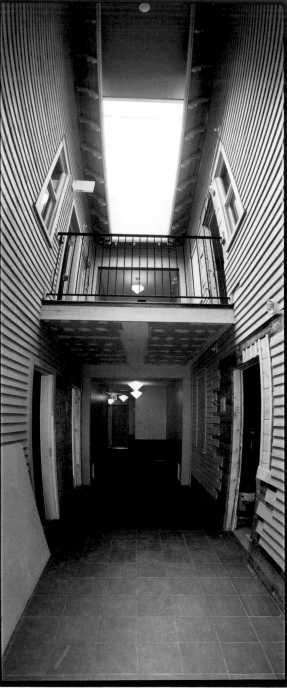

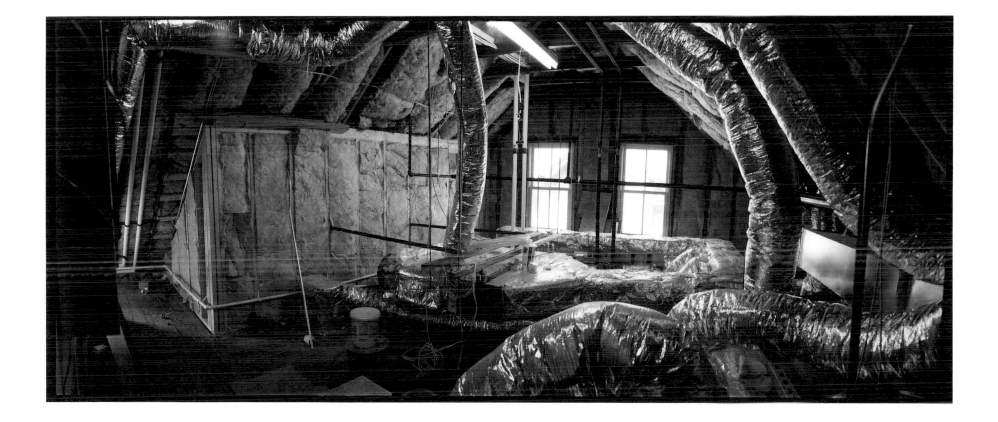

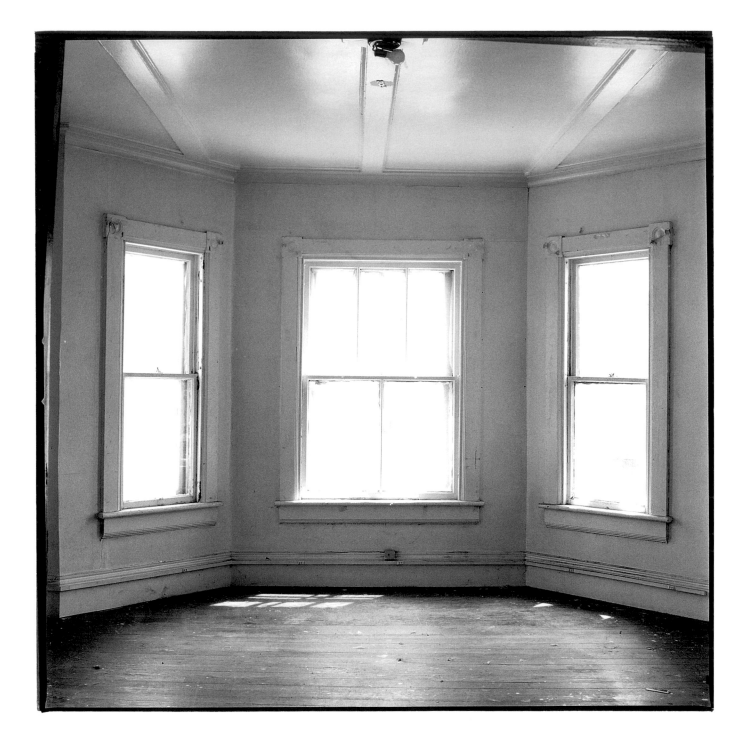

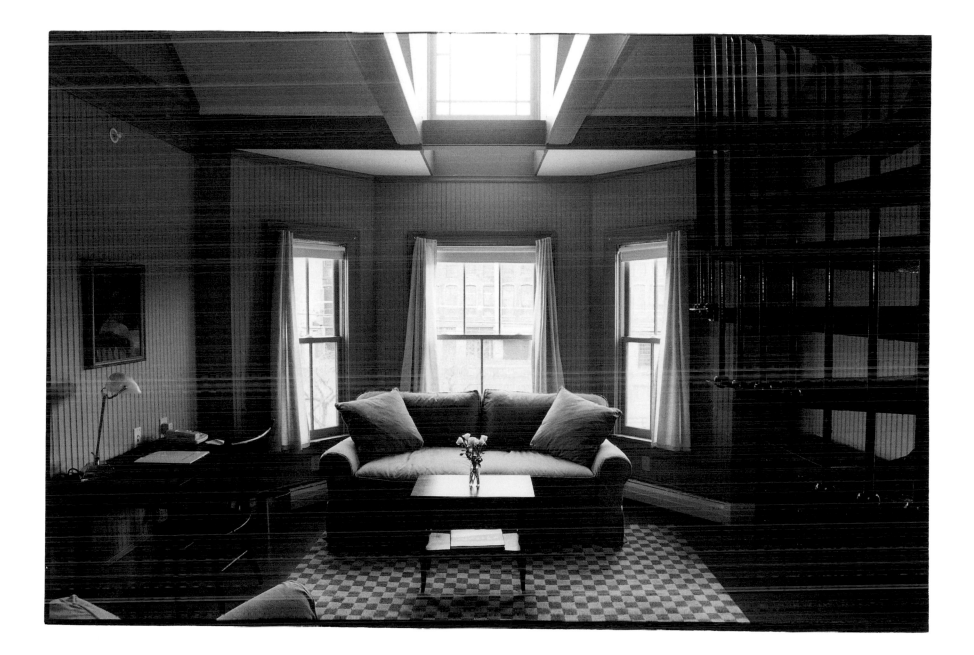

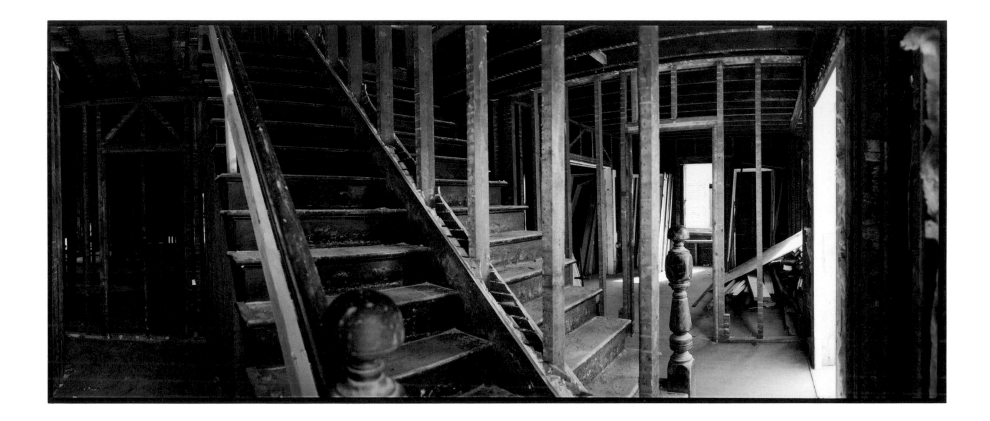

Porches: pre- and post-renovation

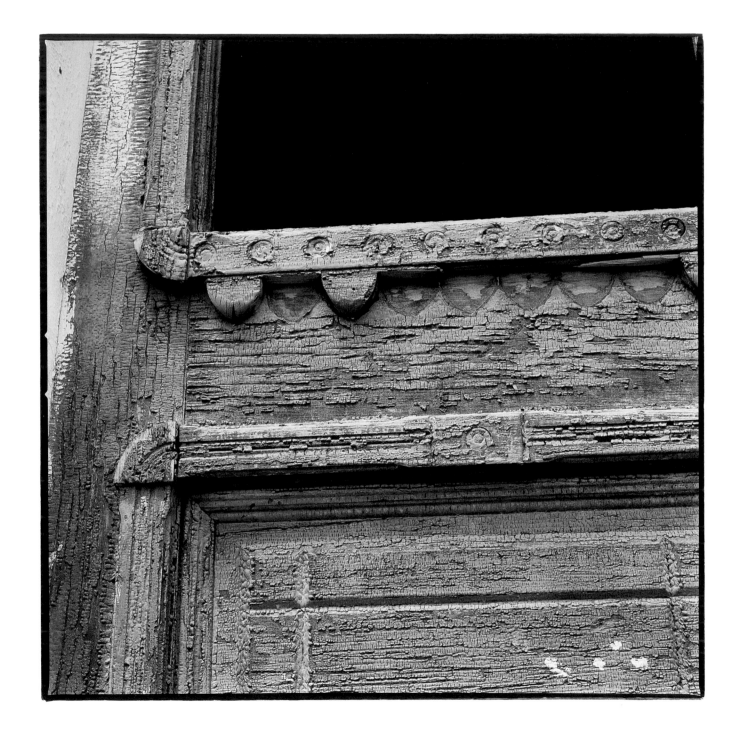

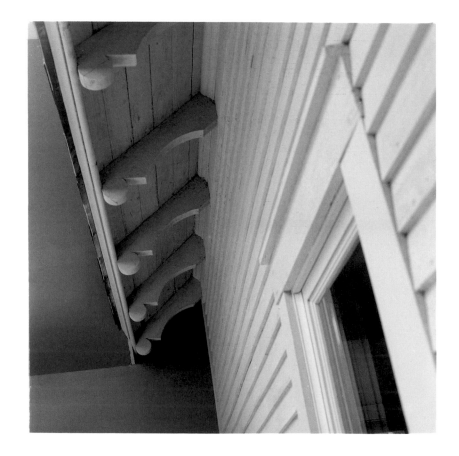

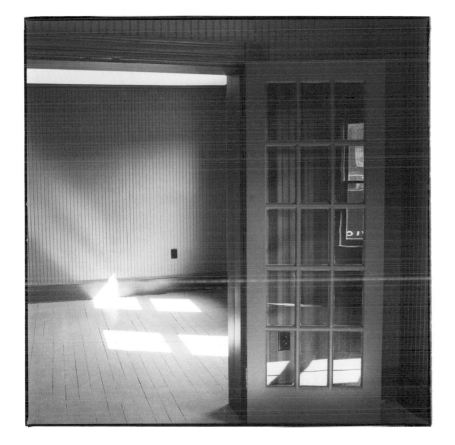

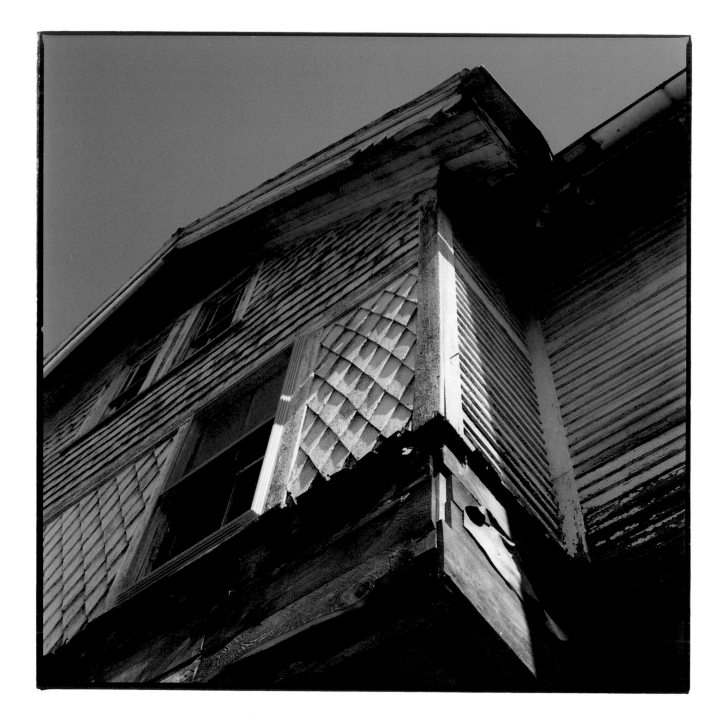

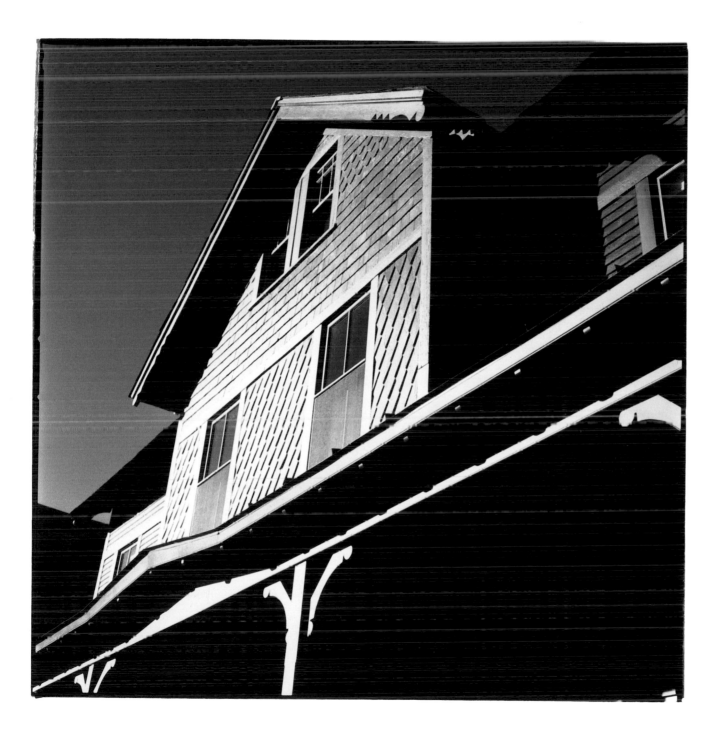

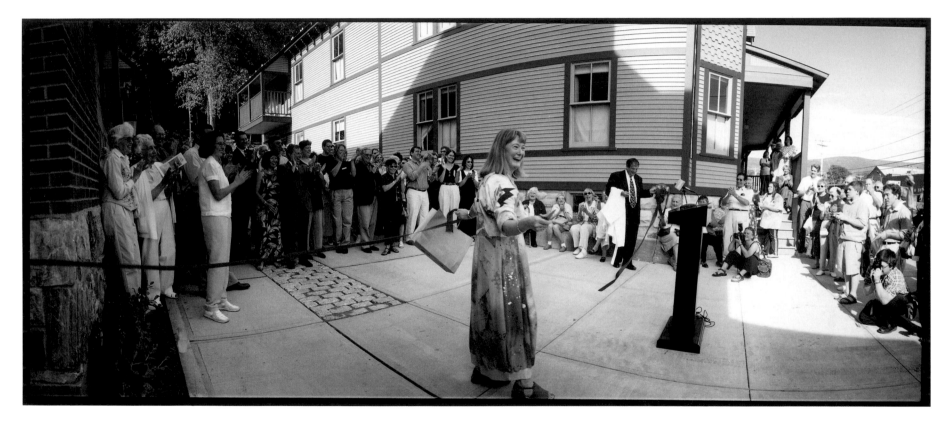

Nancy Fitzpatrick at ribbon cutting ceremony, July 2001

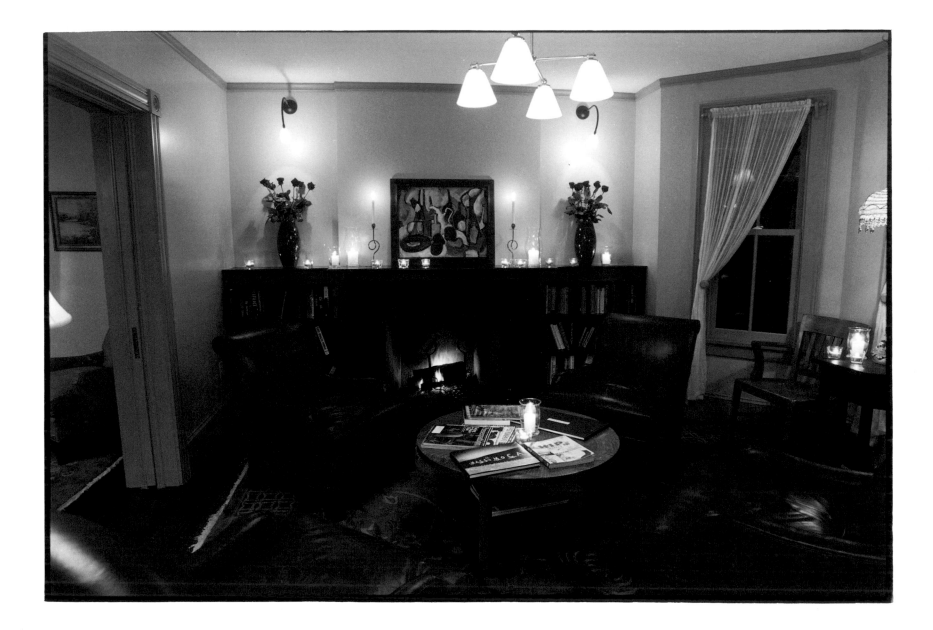

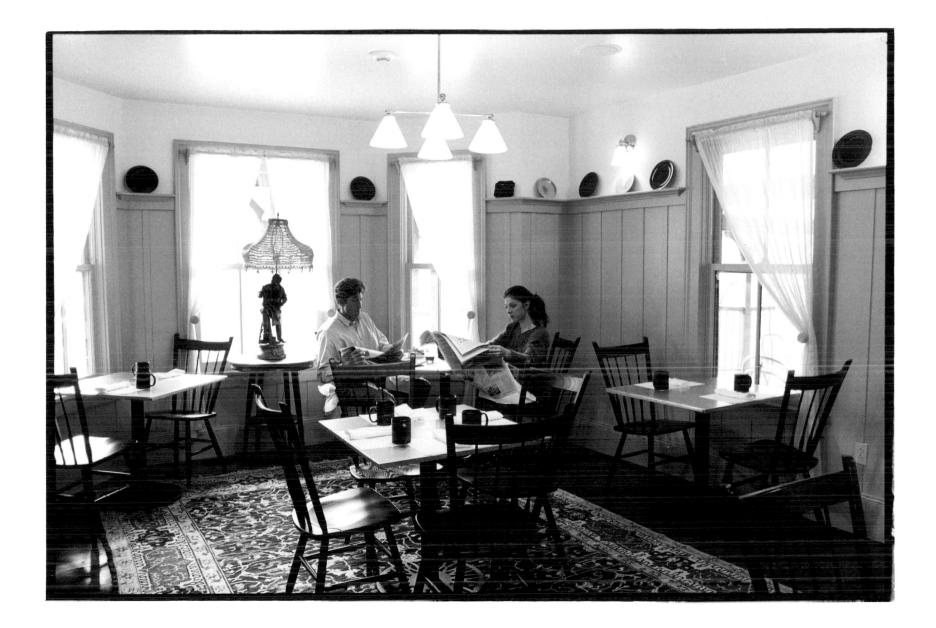

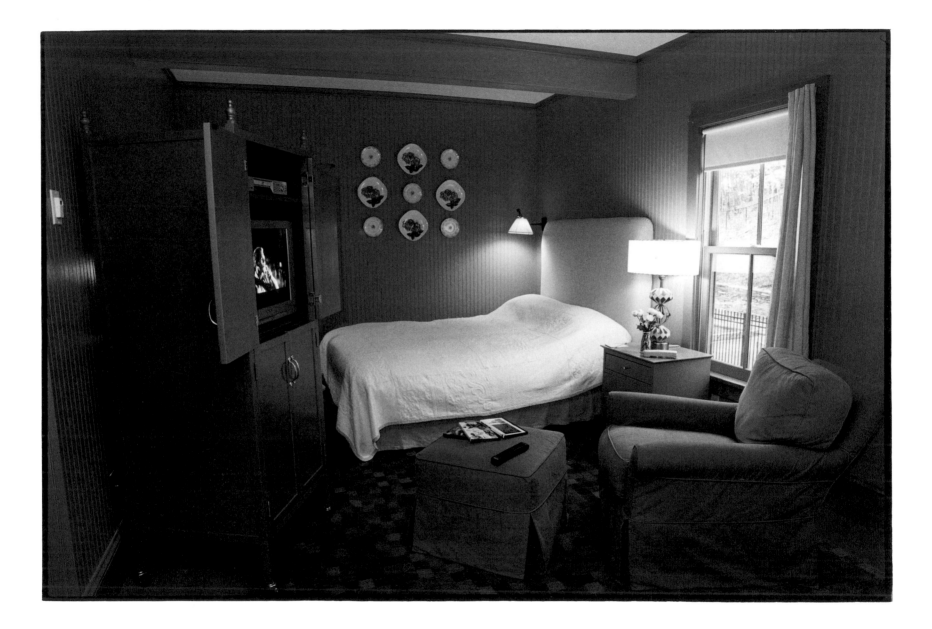

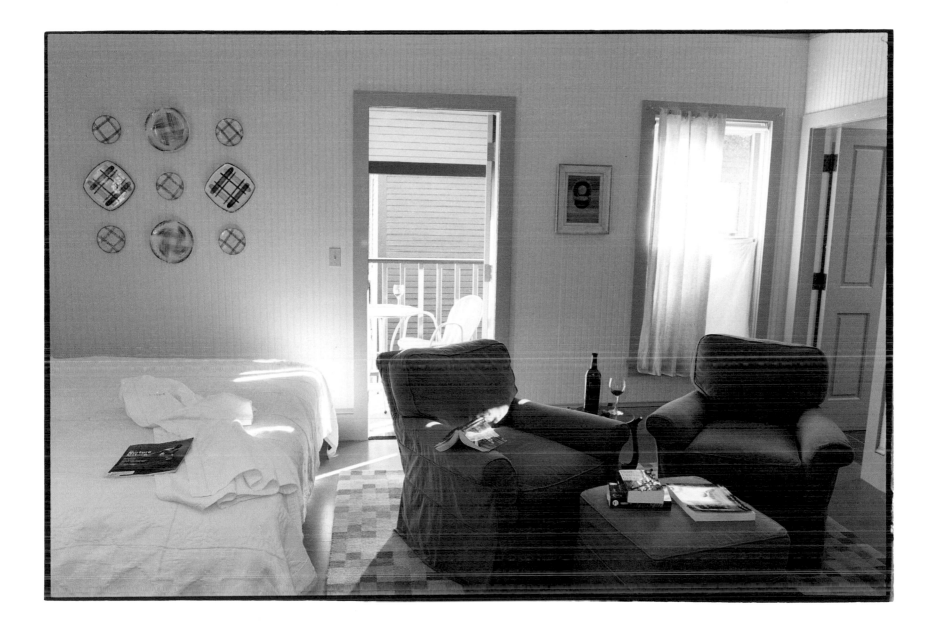

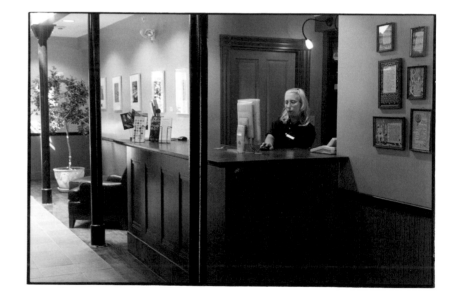

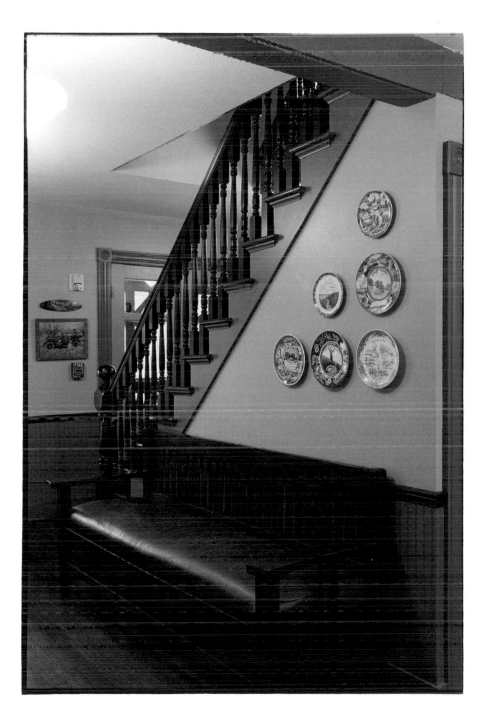

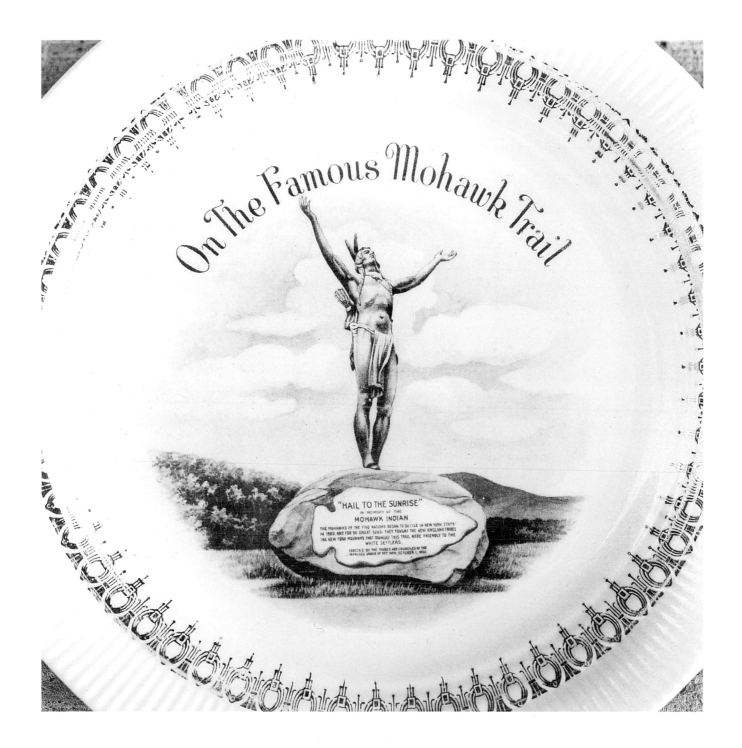

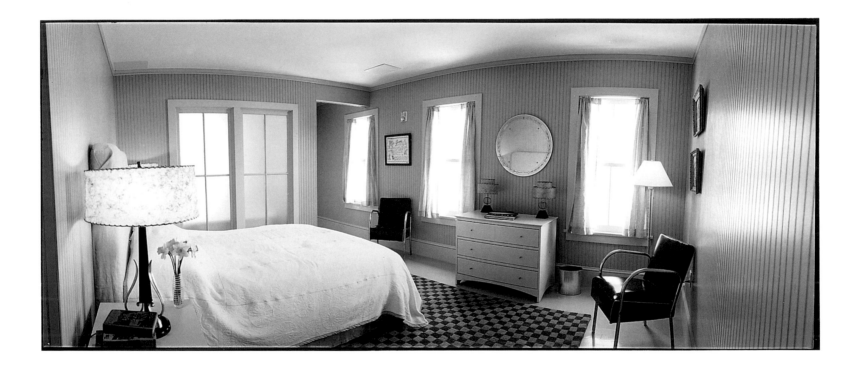

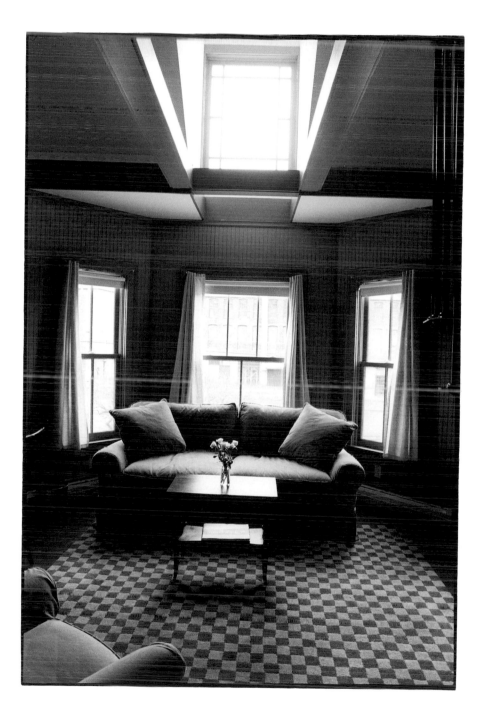

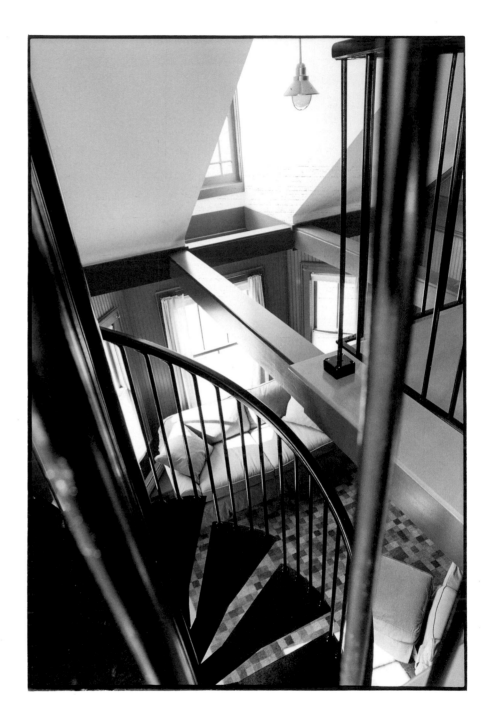

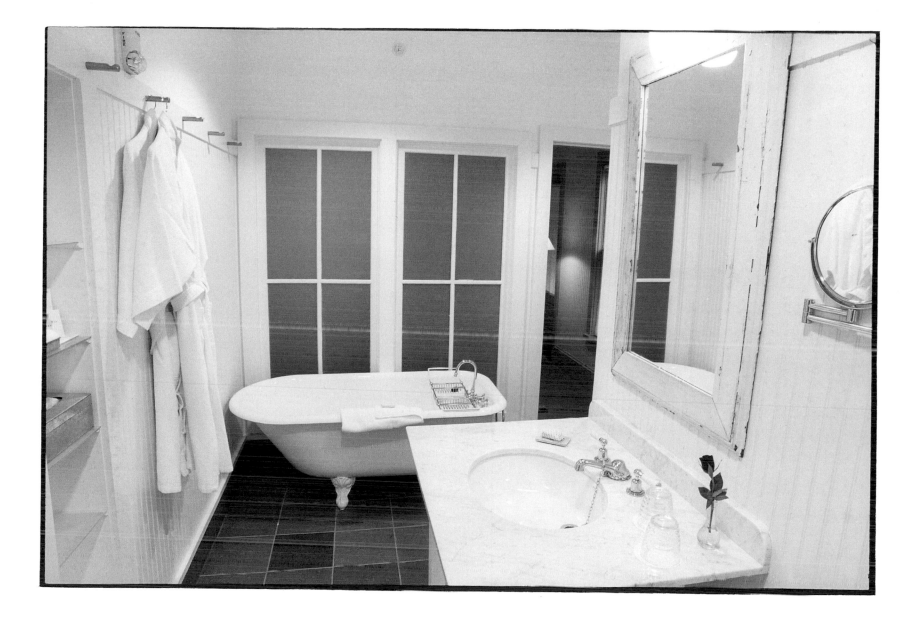

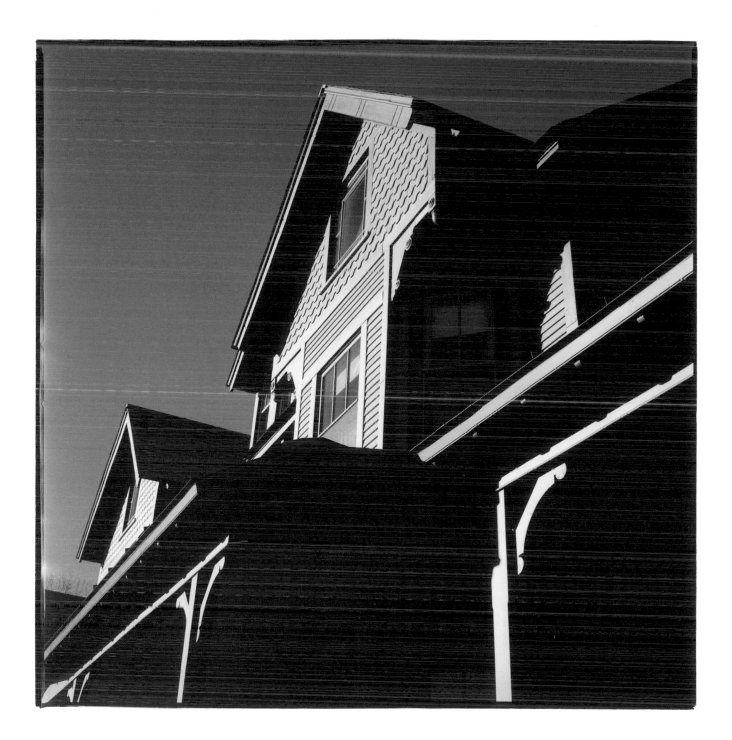

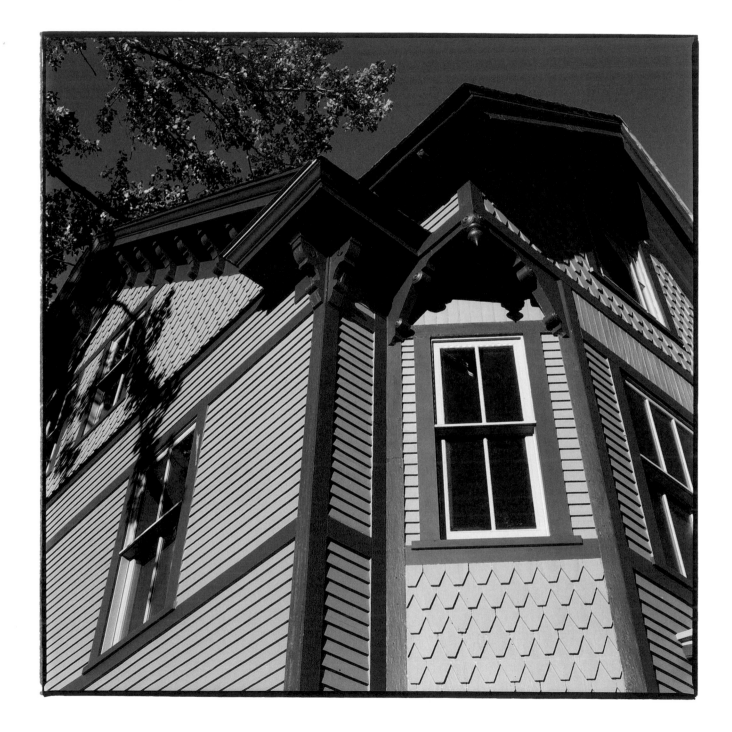

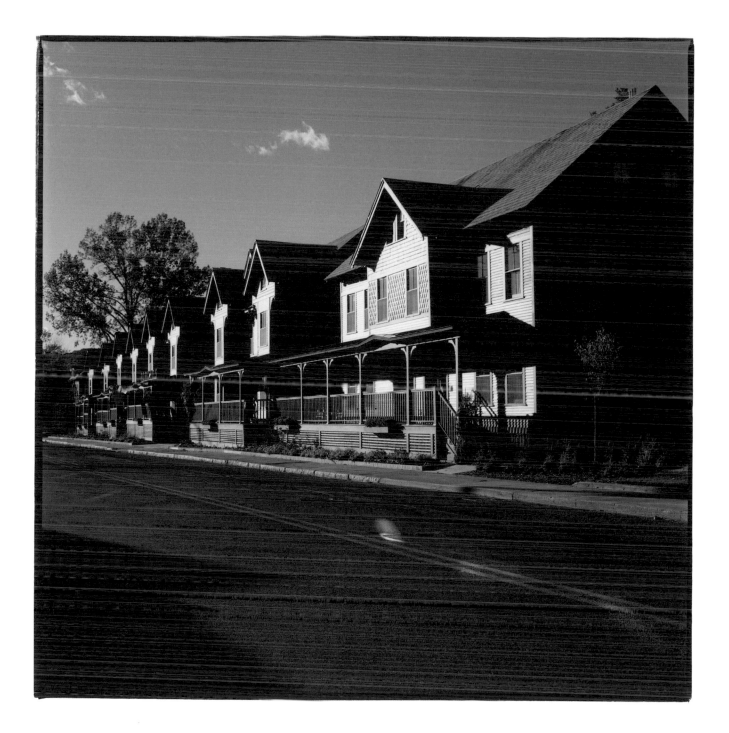

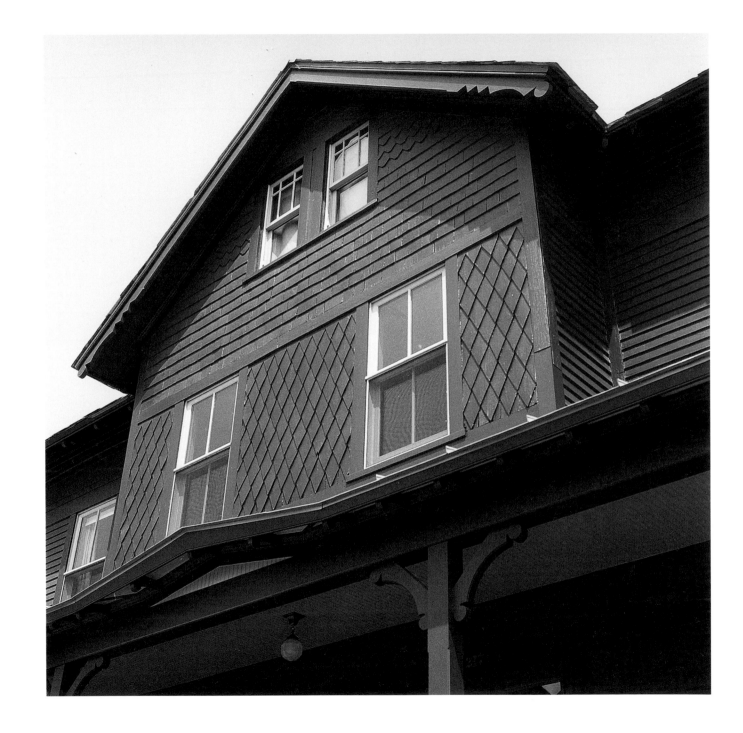

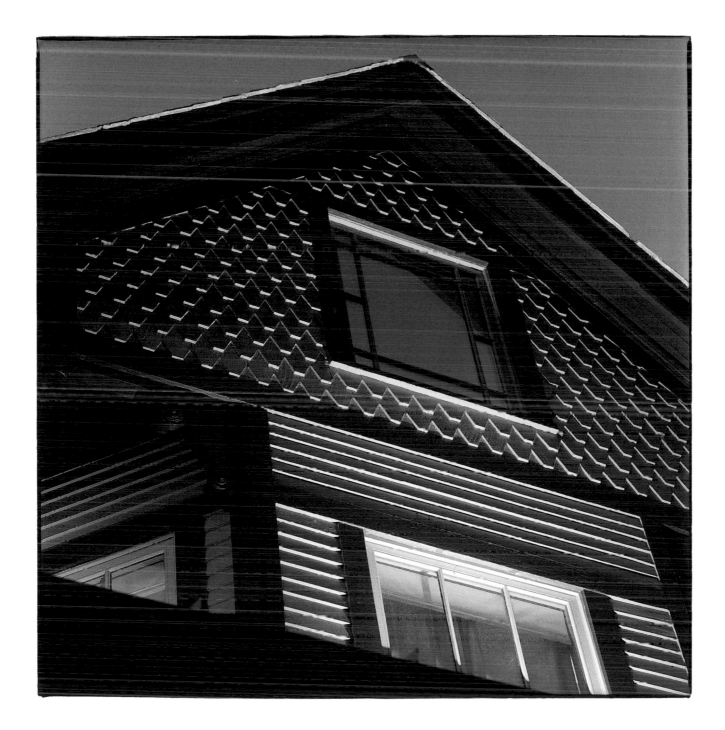

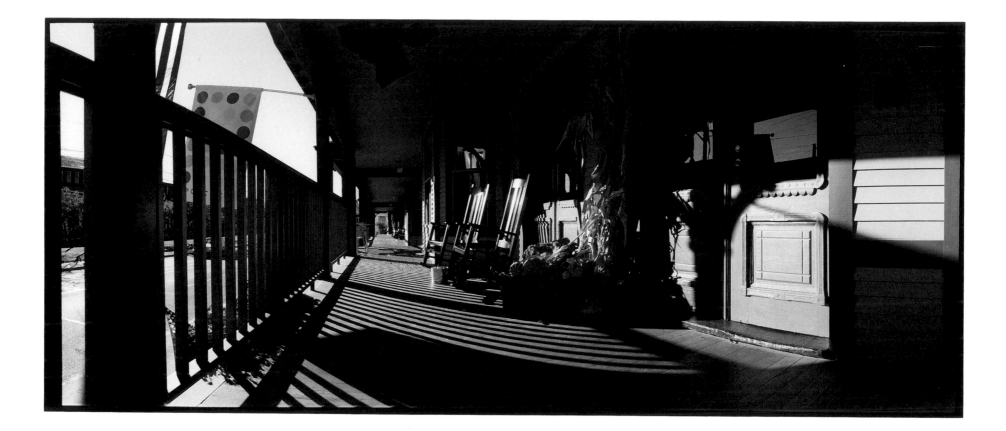

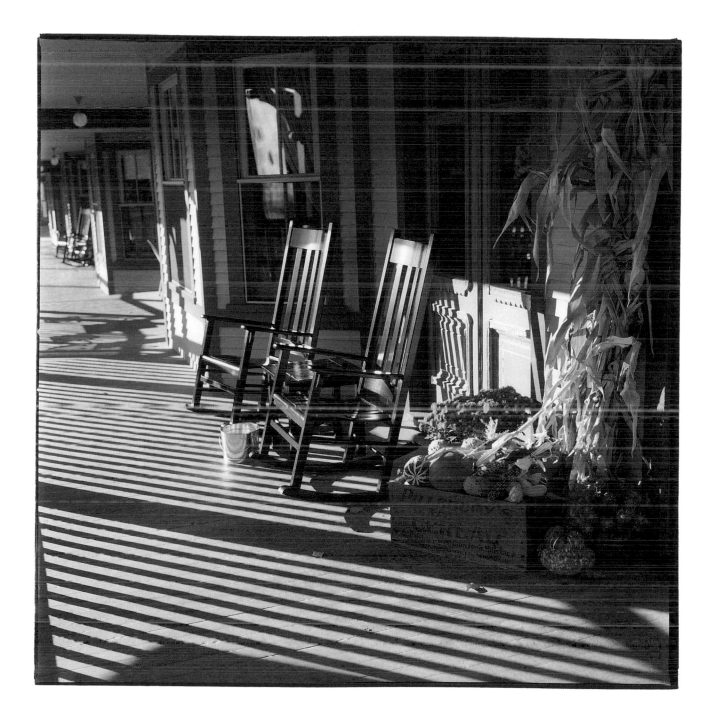

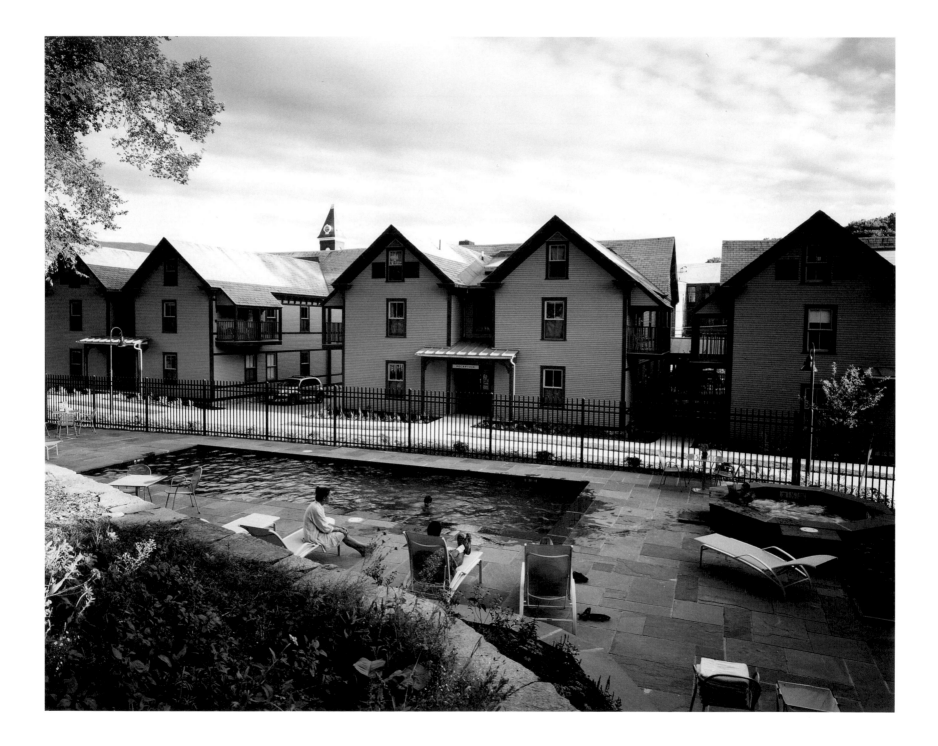

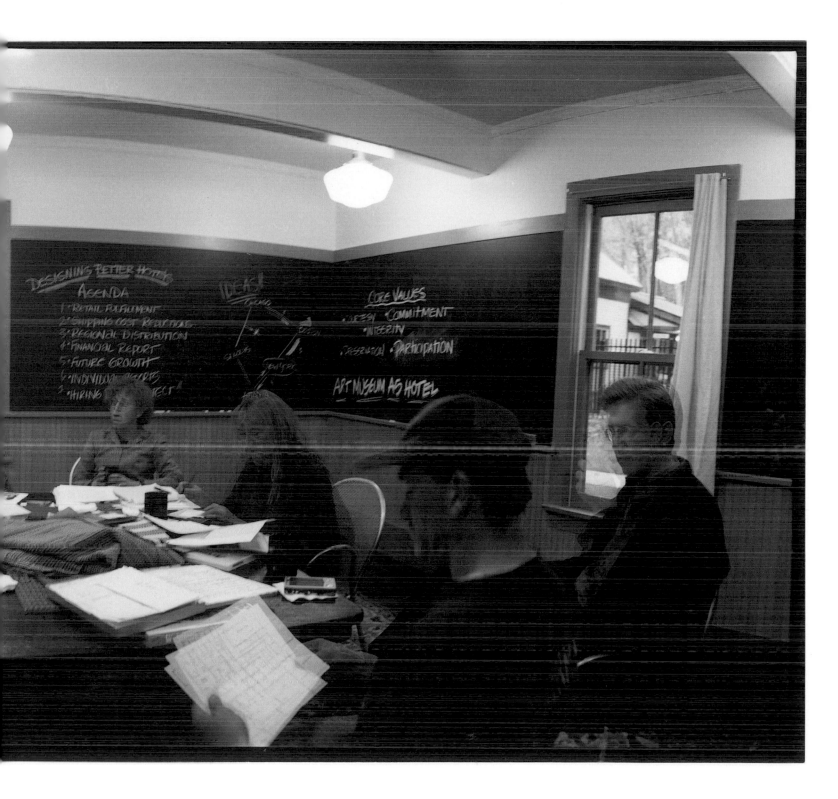

Acknowledgments

The Porches Inn was a complex and large-scale renovation project that required the skilled services of a wide range of contractors, tradespeople, designers, and vendors, and the support of many in the City of North Adams.

Berkshire Hills Development Company and The Red Lion Inn would like to thank the following for their good work:

Special thanks

City of North Adams, and most especially
 our neighbors
Mayor John Barrett III
North Adams City Council
North Adams Planning Board
North Adams Zoning Board of Appeals

Design, Engineering, & Project Planning

Burr & McCallum Architects
Denig Design Associates, Landscaping
John DeRosa, Project Attorney
Dubois & King Inc, HVAC Engineering
Eco-Genesis Corporation
Vincent Guntlow & Associates, Engineering
Mohawk Engineering
Michael Card & Son, Inc.
Cornick, Garber & Sandler LLP (accounting)
Douglas Paisley (colors consultant)
Larry Smallwood (lighting design)

The Red Lion Inn Staff

Nancy Fitzpatrick
Brooks Bradbury
Dennis Barquinero
Gary Cannon & Red Lion Inn Maintenance Staff
David Durfee
Matt Heim & Red Lion Inn Accounting Staff
Eva Sheridan
Gosia Nowaczyk & Red Lion Inn Housekeeping Staff
Jayne Church
Douglas Luf
Leann Breer & Red Lion Inn Reservations Staff
Michelle Castagnaro & Red Lion Inn Front Desk Staff
Vince McDonald
Marc Chenail
Todd Salvadore
Debbie Wiswesser
Isabelle Soule
Carla Gerros
Pam Torres
Kristin Zimmer

Porches Staff

Olivier Glattfelder
Dorothy Mason
Jennifer Plankey
Chandler Nelson
Melissa Chartrand
Tina Senecal
Bruce Bastien

Pre-Opening Associates, Vendors, and Friends

Athol Table Company
B & H Artworks, Inc.
Bart Arnold
Baths from the Past
Biasin Enterprises
Casey Fitzpatrick
Country Curtains
Country Lion Agency
Crispina Designs
Cypress Massachusetts
Danny Bell
David Fuller Cabinetmaker
Diana McGrory
Don Troy
Elisabeth Wilmers
Empire Design Studio
EMU Americas, LLC
Excelsior Printing Company
Greenwich Bay Trading Company
Harrison Gallery
Hauptman Home Products, Inc.
Housatonic Curtain Company
Hunter Lighting, Inc.

Jim Bashour / Macport
KNF:Home
Kwik Print
L. May Metal Fabricators
Lee Industries, Inc.
Lenox Door & Glass
Lillian Bender
Madlyn Easley
Mark Hernandez
Maurice Leahey
Moonshine Lamp & Shade
Northern Feather
Palmer Security Products
Pierre Verger / Gaël Armand-Grothman
Quality Printing
R.I. Fisher
Rebecca Werner & Associates
Robert Abby, Inc.
Shannon Mulvey
Tim Eustis
Trans-Ocean Import Company, Inc.
Tyndall Creek Furniture Company
UNO Community Organization
Vermont Precision Woodworks
William Caligari / Interior Design, Inc.
William Carl Marshall Designs

Construction Supervision

William Taft III, Supervisor
Bigs Waterman, Lead Contractor

Primary Contractors

Berkshire Fence Company
Boucher & Dupuis Painting Company
Champagne Drywall, Inc.
Conserve Thru Control, Inc.
Delmolino & Sons, Inc.
Dobbert Heating & Air Conditioning, Inc.
Doxsee Roofing, Inc.
Gem Electric Corporation
Gem Environmental, Inc.
Jim Picardi Cabinetmaker
Lee Audio 'n Security, Inc.
Michael T. Davine (masonry)
North Adams Sheet Metal, Inc.
North Branch Landscape Company, Inc.
O'Neil's Carpets
Pierce Construction
Snow's Services, Inc. (flooring)
Waterman Excavating, Inc.

Primary Vendors

Adam Ross Cut Stone Company, Inc.
Aldo's Paint & Wallpaper, Inc.
Ambiance Unlimited
Bendheim Architectural Glass
Berkshire Gas Company
Brown Packaging, Inc.
Bushika Sand & Gravel, Inc.
C.L. White, Inc.
Callahan Sign Company
Coakley, Pierpan, Dolan & Collins
 Insurance Agency, Inc.
County Concrete Corporation

Della Concrete Corporation
Don's Cleaning Service
Doorcraft Corporation
Duvinage Corporation –
 Mel Grant Associates, Inc.
Eastern Prehung Door
Eastman Enterprises
Laston Electronics, Inc.
H. Greenberg & Son, Inc.
H.A. George & Sons Fuel Corporation
Mark Potvin Lumber
Massachusetts Electric Company
Nicholas Whitman Photographer
Palmer Metal Products, Inc.
Pella Products, Inc.
Pittsfield Fire & Safety Company, Inc.
Pittsfield Sand & Gravel, Inc.
R.I. Baker Company, Inc. / RIBCO Supply
R.J. Murray Company, Inc.
Reggio Register Company
Repro Systems, Inc.
S & A Supply, Inc.
Stanley's Lumber & Building Supplies, Inc.
Taconic Lumber Corporation
Tech Welding Services
W.E. Aubuchon Company, Inc.
Wasco Products, Inc.
Zenith Electronics Corporation
ZEP Manufacturing Company